JEKATERINBURG
ASCHGABAT
BISCHKEK
DUSCHANBE

NEW DELHI +30'
KARACHI
COLOMBO +30'

RANGUN +30'
DHAKA

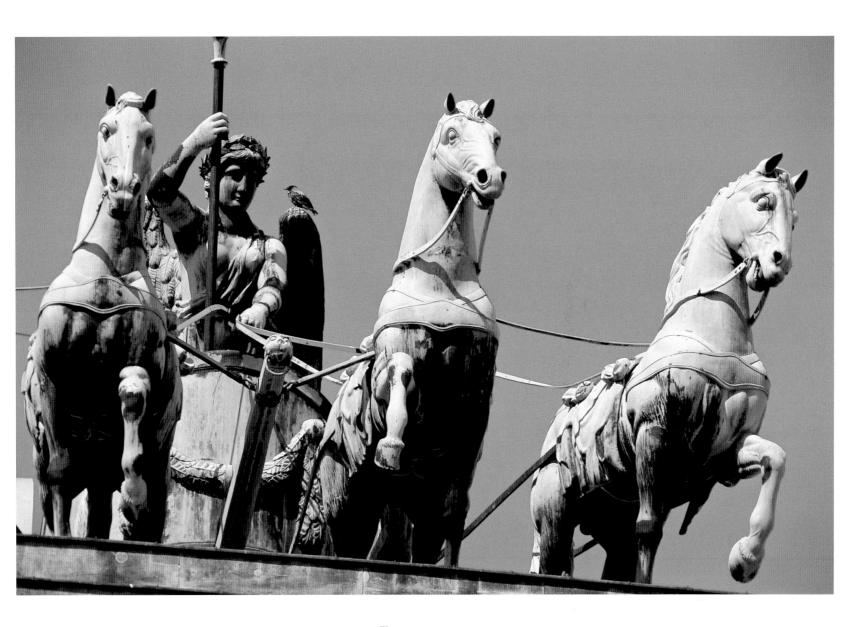

Fascinating

BERLIN

Photos by

Jürgen Henkelmann

Text by

Michael Kühler

FLECHSIG

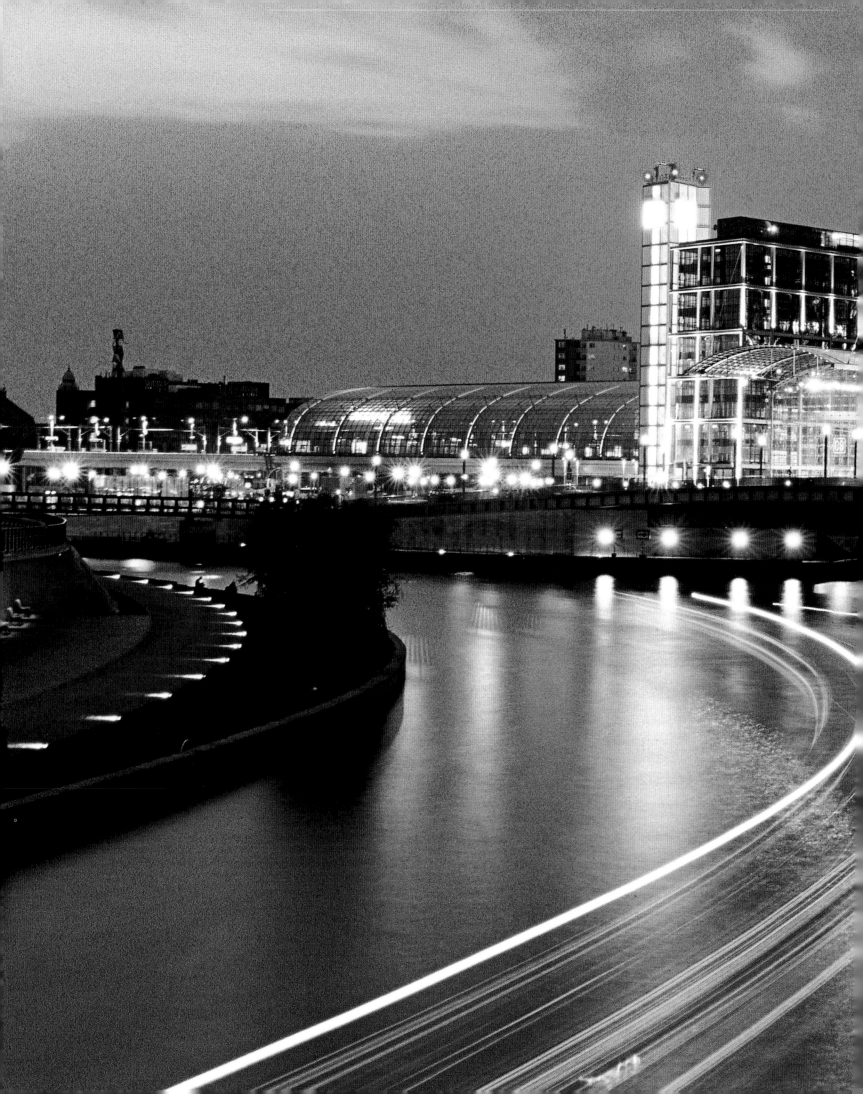

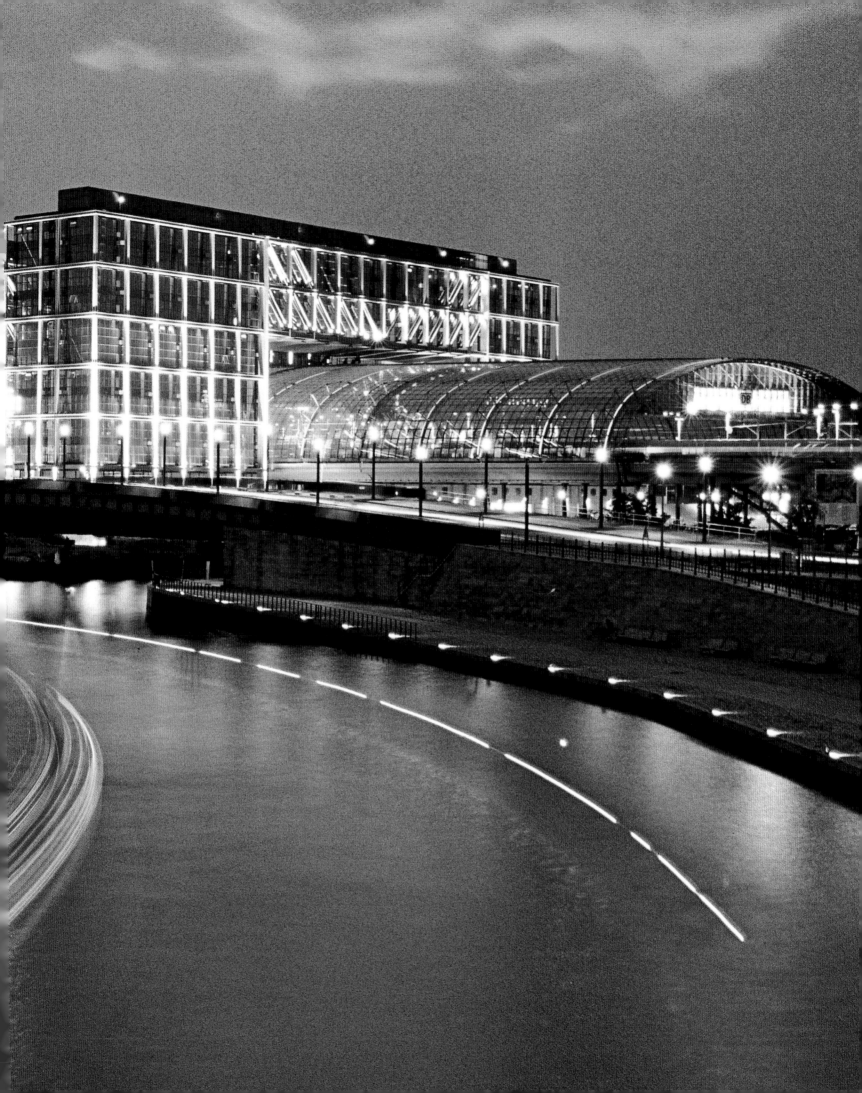

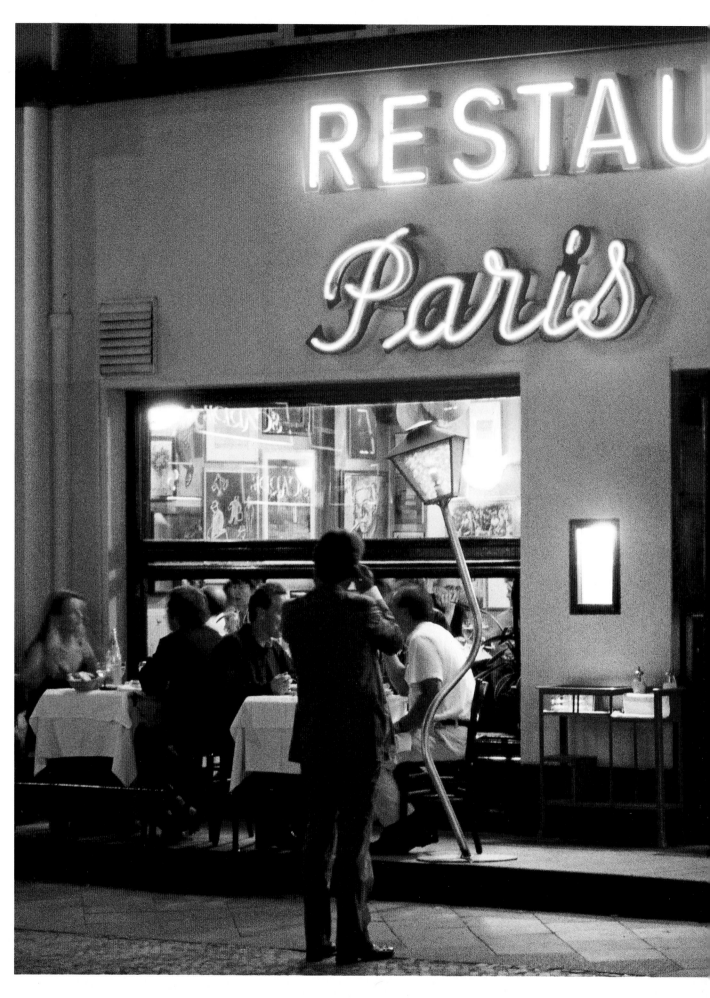

First page:
The Quadriga statue was added to the Brandenburg Gate in 1793. To commemorate his march of triumph into Berlin in 1807 Napoleon had it carted off to Paris; on the French emperor's defeat in 1814 Blüchner brought it back again. The likeness of Victoria at its centre is a copy from 1958; the original was destroyed during the Second World War.

Previous double spread:
In May 2006 Berlin's new central station was opened right opposite the chancellery. Connections to the local travel network are to be improved by the "chancellor line", a short section of underground running to the Brandenburg Gate. Drivers have direct access to the car park from the new Tiergarten road tunnel.

Right:
The Paris Bar on Kantstraße has long been something of an institution in Berlin and popular with stars and star-gazers. Its interior emulates the smoky chic of a Parisian bistro, hence the name, and the cuisine is also decidedly French.

Page 10/11:
Checkpoint Charlie bang in the middle of Berlin was famous the world over as the border crossing between East and West for Allied troops and non-Germans. A Checkpoint Charlie museum was opened in the days of the Berlin Wall; the giant photos and sandbags on the street were installed in commemoration of this historic site on the initiative of the museum's go-getting owners.

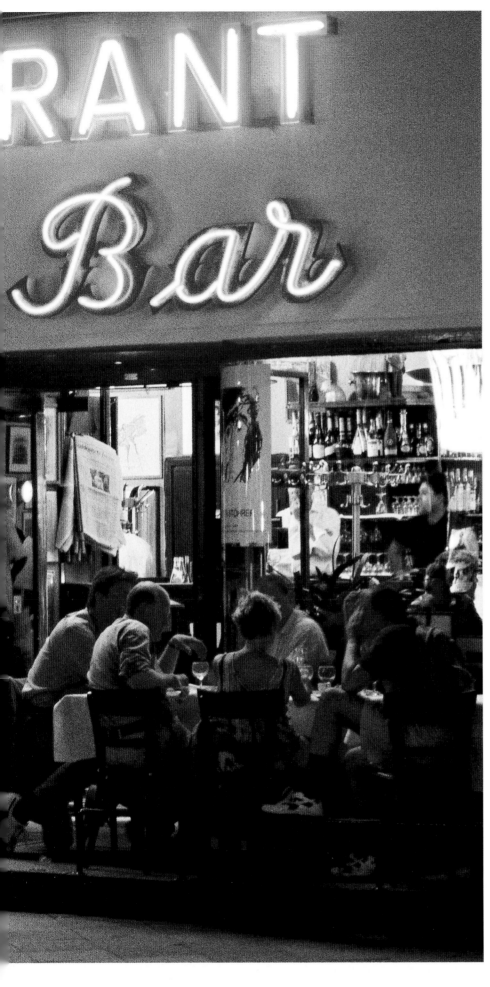

CONTENTS

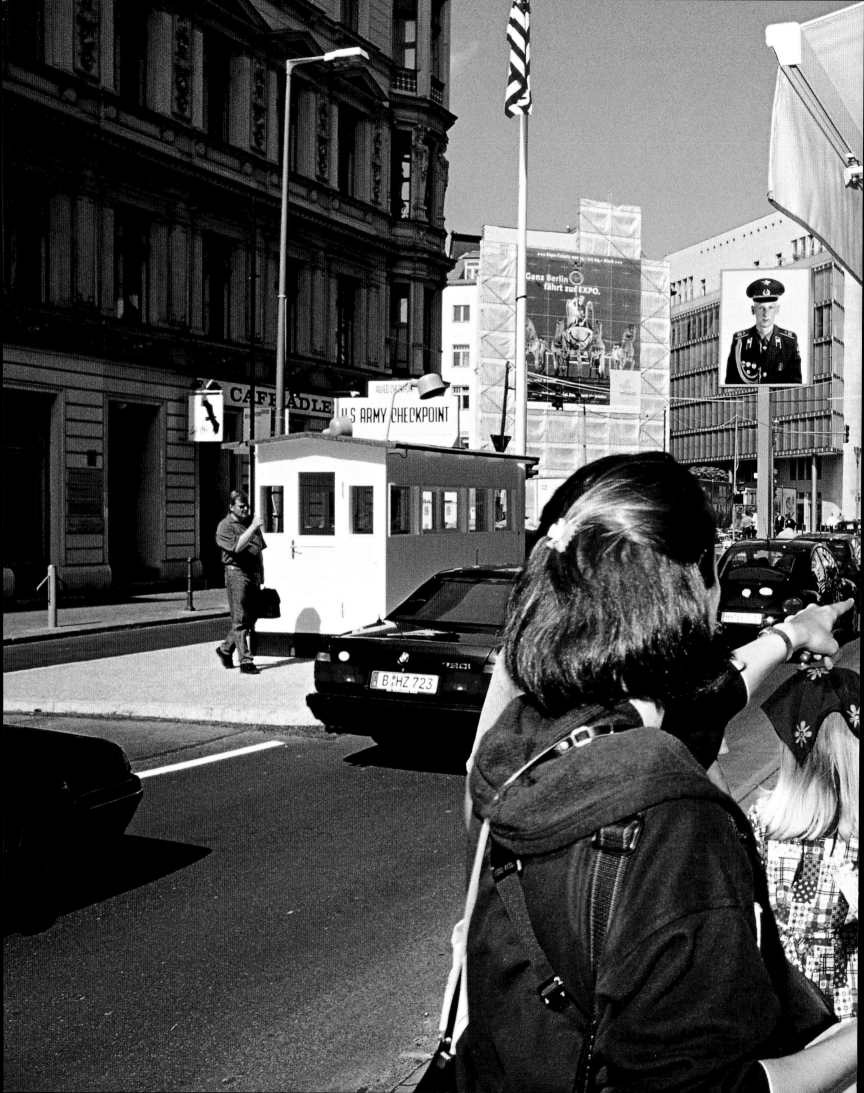

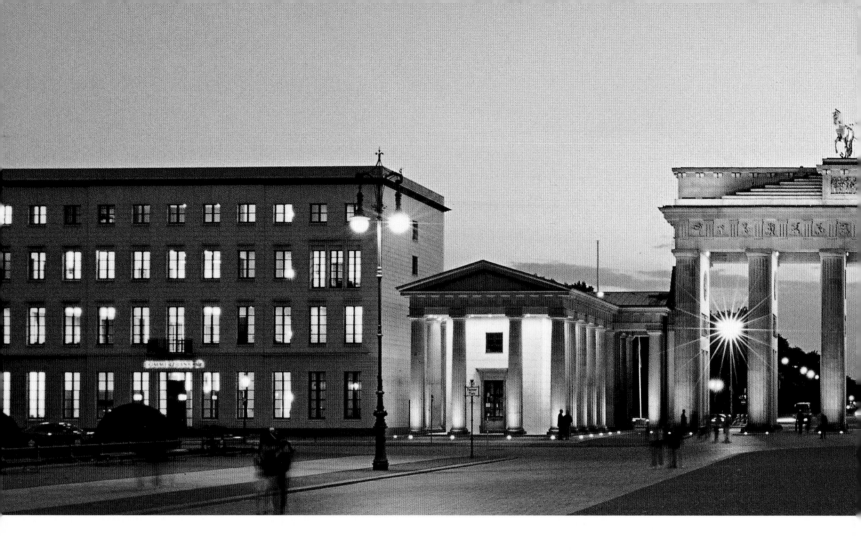

BERLIN IS DEFINITELY IN FASHION

At the end of the Prussian era Berlin chic was famous for being cheekier and more effusive than Parisian *haute couture*. By the Roaring Twenties the city had become the leading fashion metropolis of Europe. In the 1970s the liberal stronghold of punk rock sucked legends like David Bowie and Iggy Pop into its irresistible vortex. Even today Berlin is different – crazier and more colourful than other cities. It's hardly surprising, then, that

Vivienne Westwood, the *enfant terrible* and creator of punk fashion, was also one of the madding crowd, preaching her creed at Berlin's university of the arts for over twelve years. Visitors from all over the globe are also drawn to the city like a magnet by various international exhibitions, among them the Grüne Woche (agriculture, horticulture and the food industry), the Internationale Tourismus-Börse (tourism) and the Internationale Funkausstellung, the biggest exhibition of consumer electronics in the world. At the yearly Berlinale over 350 films are screened, most of them world or European premieres – for some enthusiasts a good reason to stay firmly ensconced in their plush cinema seats for the duration. See and be seen is the name of the game when the stars and starlets totter along Berlin's red carpet, lending a magical aura of fame and glamour to Germany's capital. After the show they – and all other self-respecting guests of state – are whisked off in shiny limos to the city's top hotel, the Adlon, which has been recently refurbished. Other new luxury ventures will soon join it, one of them being the Grand Hotel de Rome next to the Deutsche Staatsoper. The former headquarters of the Dresdener Bank, a listed building, is to be turned into a five-star plus establishment, redefining and surpassing all the present standards in this sector. The old strongroom will be the hotel's wellness area, complete with swimming pool, the cash hall a ballroom and the former offices of the management sumptuous suites. This all goes to show how adaptable the city is.

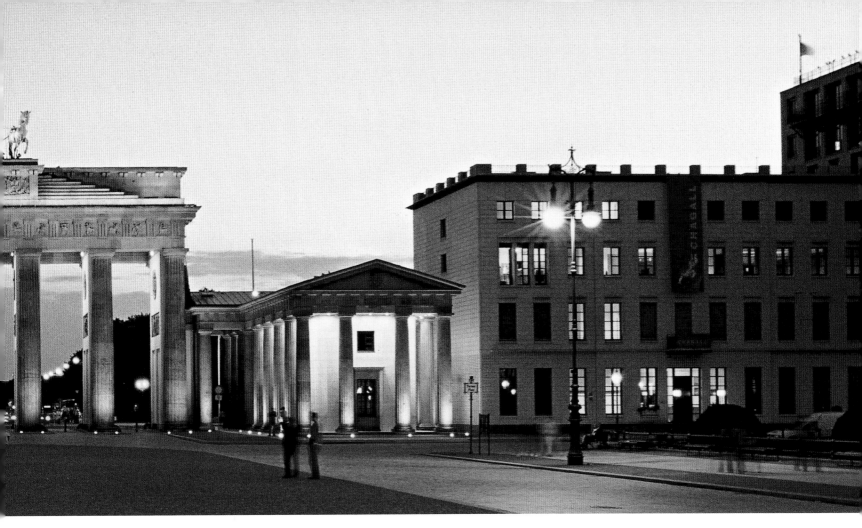

The whole city's a stage

The people of Berlin have always loved dressing up and taking on a new identity. The city's diverse new mega-events now provide them with the perfect opportunity to take to the stage and show off their acting skills. With its fantastical and colourful figures the Karneval der Kulturen pulls almost a million each time it's on and Berlin's very own Christopher Street Day Parade is no less gaudy on the costume front when hearts are most definitely worn on (psychedelic) sleeves. Germany's biggest techno party, the Love Parade, is now emulated all over the world. Other great events have been foreshadowed; following the 2006 World Cup Berlin expects over half a million visitors to the 2009 World Athletics Championships. This is the city where stations are turned into museums, where the remains of walls become open-air galleries, where old factories mutate into multifunctional events complexes. The museum of contemporary art in the old Hamburg station has long made a name for itself amongst art enthusiasts the world over and the East Side Gallery is equally famous. The latter is where in a fit of spontaneity enterprising artists, often without grounding or suitable materials, painted their view of the division and reunification of the city onto a section of the old Berlin Wall; some of the paintings, such as the well-known *Bruderkuss* or brotherly kiss, have already had to be redone. Old factories now sport trendy new names, such as Brotfabrik (the bread factory) and Kultur-

brauerei (culture brewery), and are indeed, as the name suggests, cult. In an attempt to boost the town's flagging gastronomy at the end of the Second World War closing time in pubs and restaurants was abolished – in an act which was internationally unique. Since the reunification of Germany this bylaw has been revoked; night owls are welcome to investigate just how many proprietors actually keep to the rules ...

Almost no other city has as big a variety of bars, clubs and restaurants, cafés, pubs and casinos to offer as the city on the River Spree. The Paris Bar, for example, has become something of a legend where star celebrities and would-be household names congregate. The stars which twinkle outside Berlin's gourmet temples, most of them restaurants in luxury hotels, are also fairly new to the scene, among them First Floor at the Hotel Palace, Hugos at the Hotel InterContinental and Lorenz Adlon at the Hotel Adlon. The world's only dark restaurant is also in Berlin – where else? – and the subject of some controversy. Another anomaly of a totally different nature – and still something of a personal tip – is Van Loon, an old Dutch fish cutter moored on the Landwehrkanal at the Urbanhafen.

Athens on the Spree

Water breathes life into a city. Did you know that Europe's biggest river and canal network is in Germany – with the capital slap bang in the middle?! Berlin has more waterways than any other European city and more bridges

The two resurrected neo-classical palaces flanking the Brandenburg Gate, to the left Haus Sommer and to the right Haus Liebermann, betray a distinctly modern architectural leaning. Both buildings are now used by banks who open their doors to the public when exhibitions and other events are staged here.

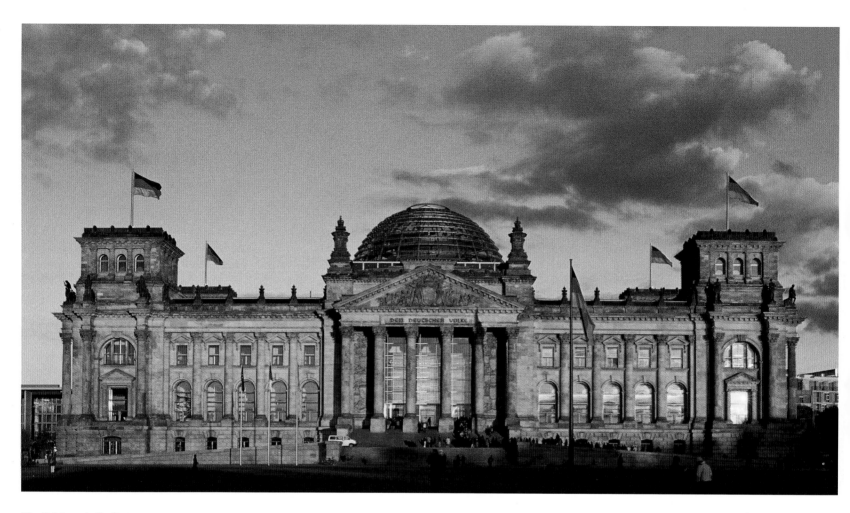

The Reichstag in Berlin is unique in that it probably attracts more custom than any other parliament building in the world. Spectacularly wrapped by Christo shortly after its reopening, the countless visitors can now stroll up to its spacious roof and enjoy the fantastic views until late into the evening.

than Venice. The maritime flair and many sights of Athens on the Spree, as Berlin is often called, can best be enjoyed aboard one of the city's pleasure boats. On a tour of the Spree and Landwehrkanal rivers you can take in the modern architecture of Potsdamer Platz and the government quarter with its Reichstag and chancellery, for example. For something really special why not take a trip after dark and see Berlin lit up at night? The name "Berlin" alone denotes its affinity with water. The word is of Slavic origin and means "a dry place on water". The origins of the first settlement here are shrouded in mystery. As in the second half of the 20th century Germany's capital was originally divided into two: the towns of Cölln and Berlin which defended a crossing on the River Spree on the road running between the two older settlements of Spandau and Köpenick. Cölln was first officially mentioned in 1237 and Berlin in 1244. The former date has formed the basis of the city's jubilee calculations and celebrations many times. Recently the city even commemorated its 750th birthday twice: once in east Berlin as the capital of the GDR and again in West Berlin. In the past few years excavations beneath the old Heiliggeist-Kapelle have revealed that the earliest settlement on the Spree dates back over 1,000 years. This would make the centre of Berlin of a similar age to its suburbs of Köpenick and Spandau. Another Berlin outpost – and also linked to Köpenick and Spoandau by water – is Zehlendorf with the famous Wannsee. Nicknamed the "bathtub of Berlin", like its counterpart the

Großer Müggelsee the lake attracts countless water sports fanatics, swimmers and daytrippers to its shores in summer. There are so many of them that the Wannsee lido has earned itself the epithet of "largest inland lake resort in Europe". The lake's sights include the Pfaueninsel and Schloss Glienicke – which is possibly best known for the nearby bridge of the same name where secret agents were exchanged during the Cold War. These days are now long gone and the rivers, canals and lakes today connect Berlin to Hamburg, to the lakes in Mecklenburg and to the Baltic Sea at Stettin. Frankfurt an der Oder and the popular Spreewald are even closer. The Mittellandkanal and Elbe-Havel-Kanal even forge a link between Berlin and the River Rhine.

Nefertiti moves house

The first settlers in Cölln came from the Rhine. French Huguenots and religious refugees from Bohemia also relocated to liberal Berlin. And in the summer of 2005 Berlin's best known and most 'beautiful' inhabitant also decided to move; Egyptian queen Nefertiti was on the lookout for a new home. The Egyptian Museum in Charlottenburg was closed and reopened on a temporary basis inside the Altes Museum on Berlin's museum island. This was an important milestone in the restructuring of the Museumsinsel which at 1.5 billion euros is Germany's biggest cultural investment.

Moving is otherwise nothing special for the people of Berlin. According to statistics they move every eight

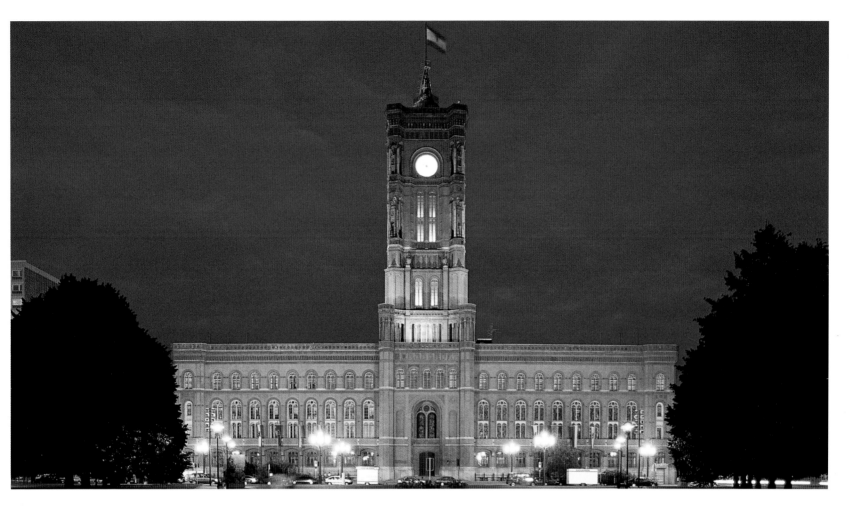

years or so, with flats changing hands faster in the confines of the inner city than in the greener suburbs on the edge of town. This flexibility, this constant reorientation and sense of change is what keeps the city and its citizens young and lively. This explains why the move of the German capital from Bonn on the Rhine to Berlin on the Spree was a relatively smooth undertaking. The refurbishing of the Reichstag – now a first-class tourist attraction with its glass dome – is history. The new chancellery on Willi-Brandt-Straße, planned under Helmut Kohl and first inhabited by Gerhard Schröder, is now home to Germany's first woman chancellor Angela Merkel. And even what was once the biggest building site in Europe has now been tidied away; awoken from its deep slumber Potsdamer Platz, with Leipziger Platz soon to join it, is once again at the pulsating heart of town. A veritable shopper's paradise now runs from Leipziger Straße along Friedrichstraße to the magnificent boulevard of Unter den Linden, risen like a phoenix from the ashes. The latter, its west end terminating in the Brandenburg Gate which has become a world-wide symbol of peace and freedom, reaches eastwards to the old city palace of Berlin. The Stadtschloss, to give it its proper name, was badly damaged during the Second World War and torn down under East Germany's Walter Ulbricht. In its place the Palast der Republik was erected – the beige-tinted GDR parliament building also known in the local vernacular as Palazzo Prozzo or Erich's Lamp Shop (in reference to one-time head of state Erich

Honecker). According to a resolution passed in 2003 the palace is to be rebuilt and Berlin given back its historic centrepiece. Berlin cathedral has already been restored, whereas the architectural master plan for the Museumsinsel, now a UNESCO World Heritage Site, is still in the throes of implementation. Like doctors performing open heart surgery the building teams have to circumvent the hoards of visitors flocking to the museums which are still open for business. The various sections will be completed one after another, with exhibits occasionally being moved out of the way of the sledgehammers and concrete mixers. The climax of the entire project will undoubtedly be the (hopefully final) move of Nefertiti to the Neues Museum where she will continue to coolly appreciate the fascinated stares of countless museum-goers for many years to come.

Big mouth, big heart

Throughout the rest of the republic the word "cool" is also attached to the brash manner the people of Berlin are famous for. They may be loud mouthed but they also have big hearts. Berliners also love to get to the point and have invented a host of fitting nicknames for many of their landmarks. The Socialist Palast der Republik or palace of the republic has already been mentioned in this context, the GDR's government headquarters which also had a centre for literary readings and a theatre and staged cultural events for the general edification of the public. The Schwangere Auster or pregnant oyster, the

One of Germany's most famous city halls is the Rotes Rathaus in the centre of Berlin. The local designation of "red town hall" is not a reference to the GDR period, however, but to its red brick facade. Since the reunification of Germany it has been home to the provincial Berlin government.

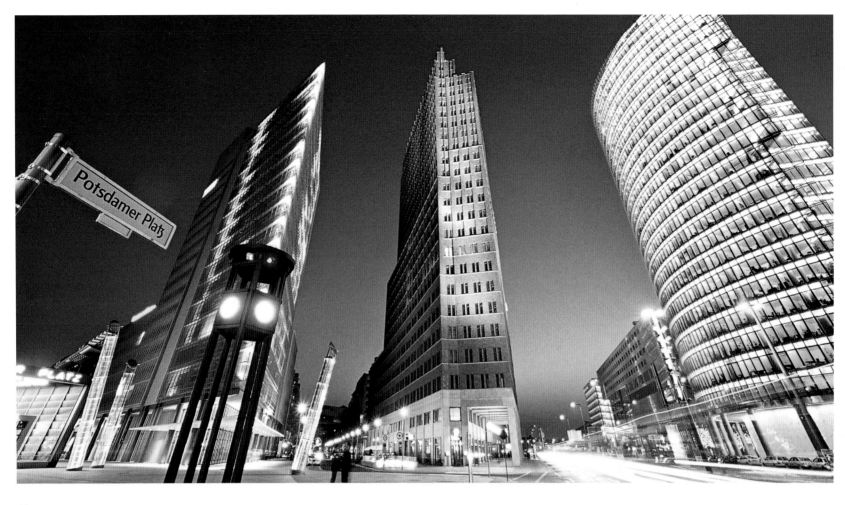

congress centre, part of which collapsed and has since been reopened as the Haus der Kulturen der Welt, and the Wasserklops fountain outside the Europa-Zentrum on Kurfürstendamm are also famous. This "new West", the long Kurfürstendamm with its various offshoots, became a boulevard par excellence during the 1920s. Chic boutiques and department stores, starting with the KadeWe or Kaufhaus des Westens on Wittenbergplatz, lined and still line the Ku'Damm with its many pubs and arty cafés. Maybe that's why in the local dialect the people of Berlin never simply cross a road but go "over the Damm".

The Roaring Twenties

During the 1920s Heinrich Zille wrote a very famous – and also critical – description of local culture or the *Milljöh* (milieu) in Berlin. The golden age of the Twenties was brightly illuminated by the glamorous world of entertainment. Cosmopolitan Berlin was a veritable breeding ground for bars, cabarets and vaudeville theatres of renown, such as the Klub Weiße Maus where people wore masks by way of disguise, or the Celly-de-Rheidt Ballet, the first naked dance troupe in Germany. Big names, such as Bertolt Brecht, Max Reinhardt, Kurt Weill and Gustaf Gründgens, were inextricably linked to the stage in Berlin. The relatively young medium of film also helped established a long tradition peppered with illustrious names such as Marlene Dietrich, Ernst Lubitsch and Emil Jannings. The new museum of film on

Potsdamer Platz is dedicated to diva Dietrich and has proved an absolute tourist magnet since its opening. Following the First World War Berlin became the melting pot of Europe. Emigrants from all over the world joined the merry throng, adding their brand of art to the cultural melange. The Dadaists were based here, as were Die Brücke with Ernst Ludwig Kirchner, Karl Schmidt-Rottluff and Emil Nolde and various others. On the literary front our image of Berlin has been permanently moulded by Alfred Döblin's novel *Berlin Alexanderplatz*. The city's great tradition as a centre of culture lives on in the new capital of Germany. Now that the European Union has expanded east Berlin is once again at the heart of Europe. And it has all the makings of a truly European metropolis.

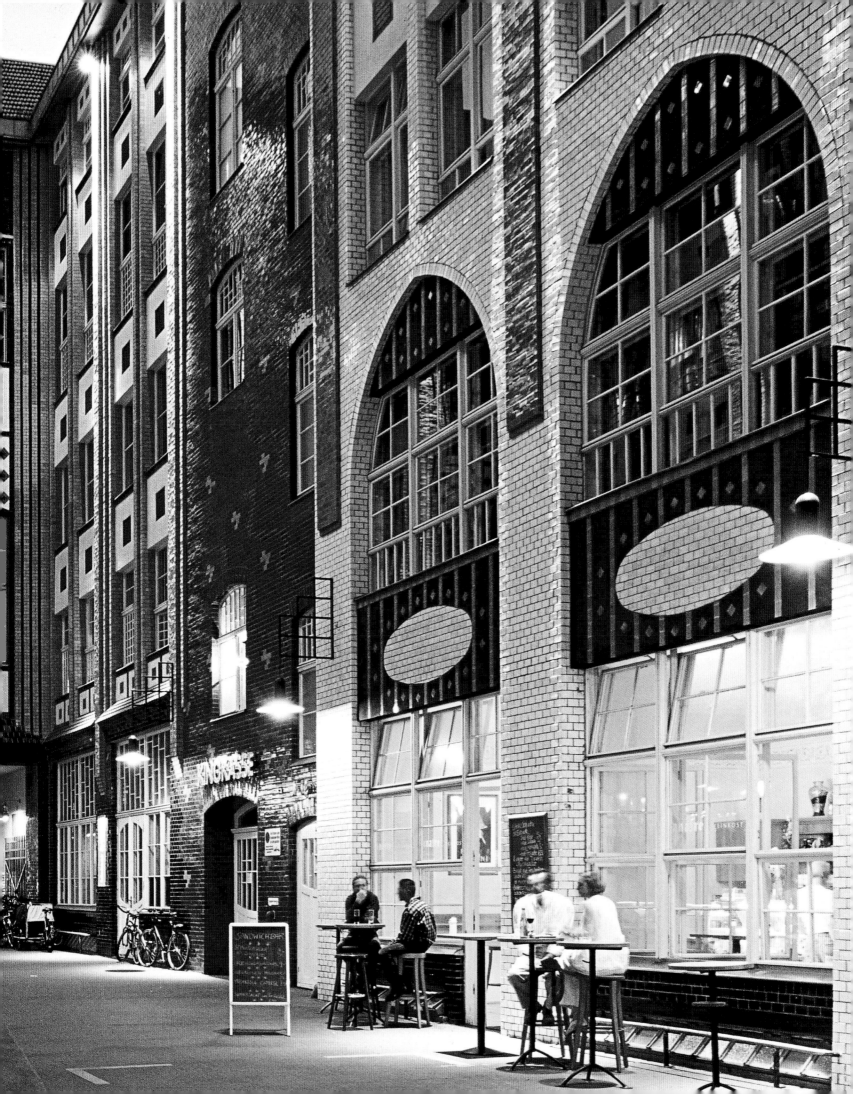

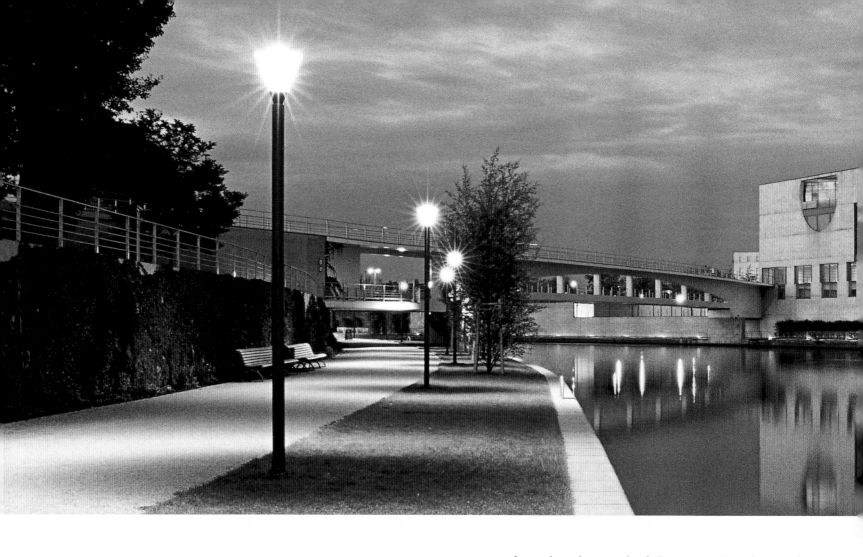

THE HEART OF THE METROPOLIS

Following the move of the German government from the Rhine to the Spree and the city's transformation from industrial big smoke to cultural metropolis Berlin's powers of magnetism have positively escalated, attracting artists, innovative service providers and curious tourists in droves. The conurbation has become not just the political capital – noticeable in the increasing number of roads cordoned off for visiting heads of state – but also the cultural capital of Germany. Brand new shopping boulevards such as Q206 smartly tout for custom, as do long-established and newfangled arts venues catering for all tastes and persuasions. The rebuilding of the Museumsinsel is also being followed with great trepidation and – typical for Berlin – has become something of a happening.

Berlin's calendar of events is not to be sniffed at; with up to 1,500 functions a day you are definitely spoilt for choice. With over 175 museums and collections, three opera houses, eight professional symphony orchestras, over 150 theatres, ca. 300 galleries, around 130 cinemas and many more facilities Berlin has long ceased to be the "secret" cultural capital of Europe!

Like no other city Berlin has the scars of its turbulent past ingrained deep in its skin. A number of different city centres, the destruction of war and the post-war era, division, reunification and a new role as national capital have produced a city where any number of architectural styles – from Prussian neo-classicism to the quirks of post-modernism – are squeezed into in a very confined space indeed. The diverse constructions thrown up during the 'rebirth' of Potsdamer Platz have found as broad an international reception as the new Jewish Museum, for example, or the total refurbishment of historic architectural ensembles such as the Hackesche Höfe. Berlin has become both a cultural metropolis and a mecca for the executors and appreciators of contemporary architecture.

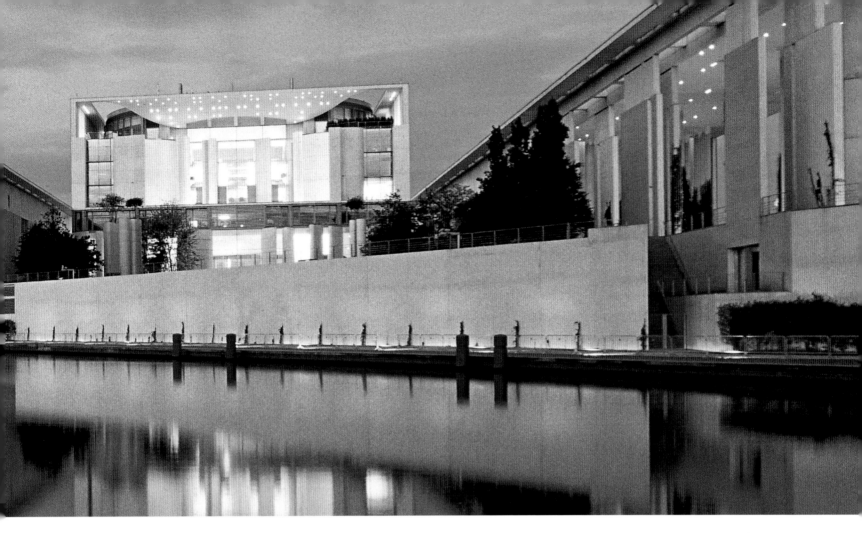

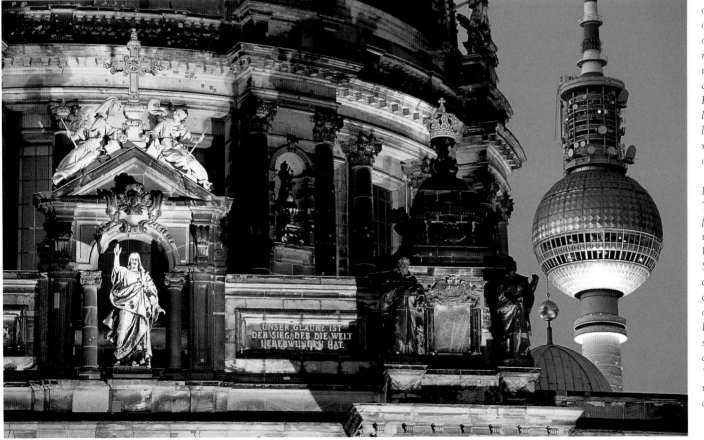

Above:
Because of its semicircular opening the Kanzleramt or chancellery in Berlin is often called the "washing machine". It was planned under the former German chancellor Helmut Kohl. Having turned out a little on the large side the local populace also jokingly refers to it as the Kohlosseum…

Left:
Two Berlin landmarks, photographed from an unusual perspective. Unlike the dynamited Stadtschloss the imperial cathedral has been rebuilt, complete with its array of ornaments and statues. Beyond it the GDR television tower, known locally as the Telespargel or "TV asparagus", gently revolves around its own axis.

The Brandenburg Gate seen from a number of angles: from Pariser Platz (right), Tiergarten (bottom) and a detail on Pariser Platz (right page). King Friedrich Wilhelm II wanted a grand gateway to pass under on his way from his palace in Berlin to his domicile in Charlottenburg. The new edifice was to demonstrate as much openness and transparency as possible. Taking the Propylaea in Athens as his model, Carl Gotthard Langhans created a Doric colonnade with pillars from sandstone, an unusual building material for Berlin. The two low wings acted as a guardroom and customs post. Even before the mammoth project was begun Langhans had planned that a statue alluding to Greek mythology should form the centrepiece of his magnificent archway. In recent years his creation was most famously in the public eye on June 12, 1987, when US president Ronald Reagan demanded: "Mr Gorbachov, open this gate!". Two years later his words were heeded – and the Brandenburg Gate restored to the centre of both halves of Berlin.

Page 24/25:
Berlin's showpiece boulevard, Unter den Linden, begins at the Schlossbrücke, the old palace bridge adorned with figures in white Carrara marble which were designed by Schinkel and executed by eight different sculptors. To the left is the old military headquarters and to the right the armoury which now accommodates the Deutsches Historisches Museum, Germany's museum of history.

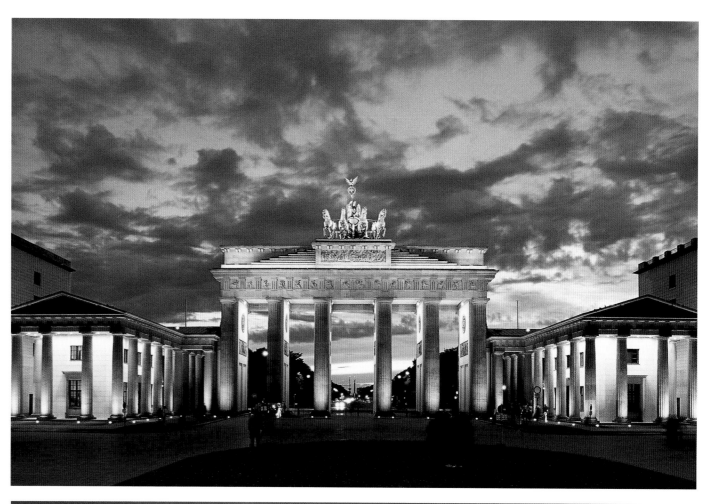

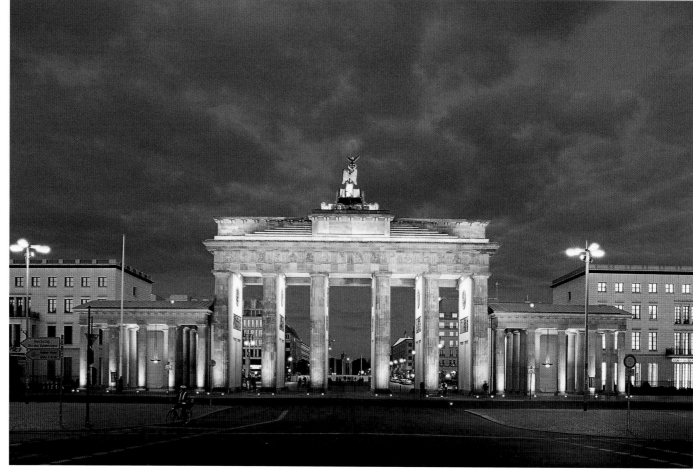

22

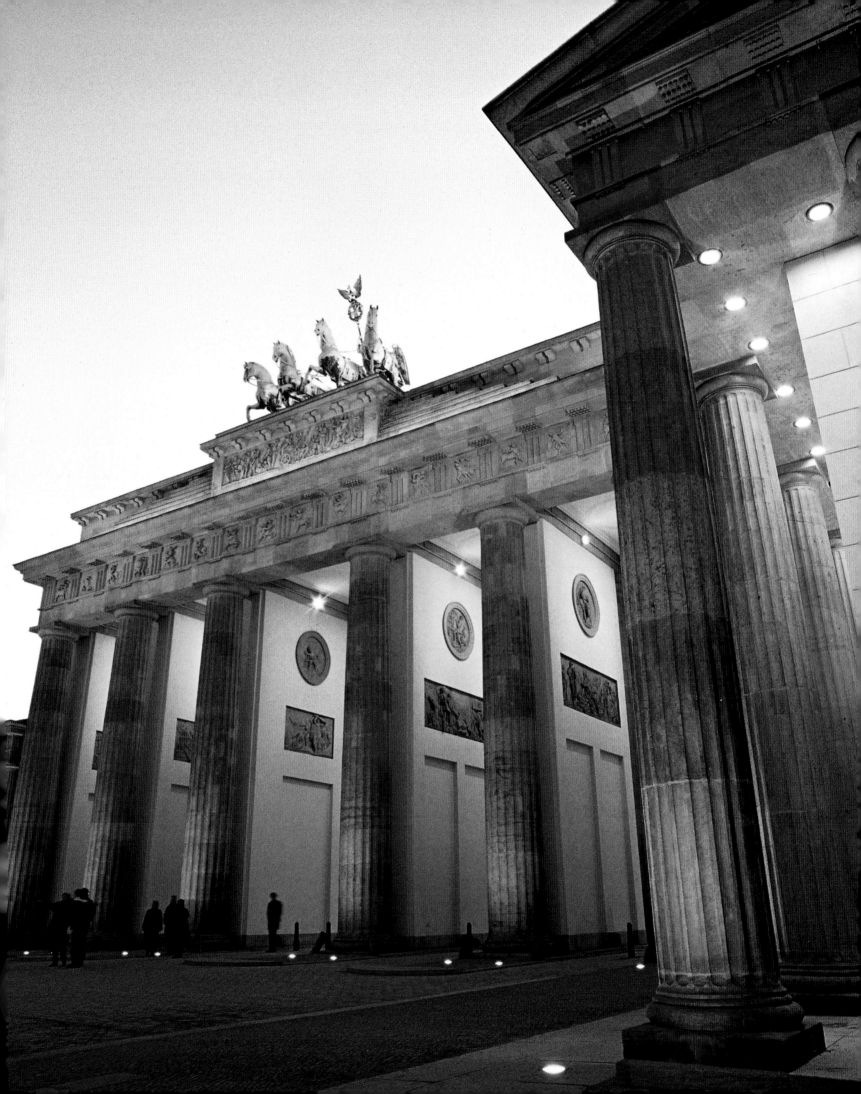

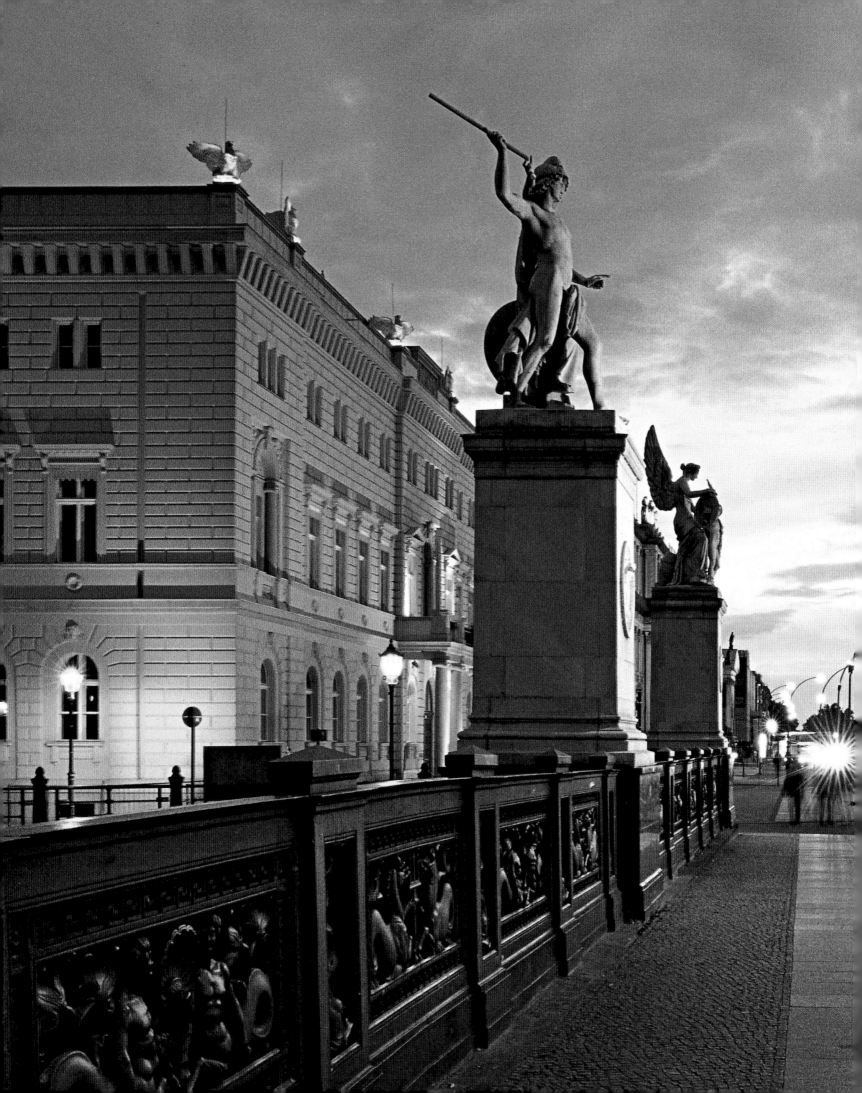

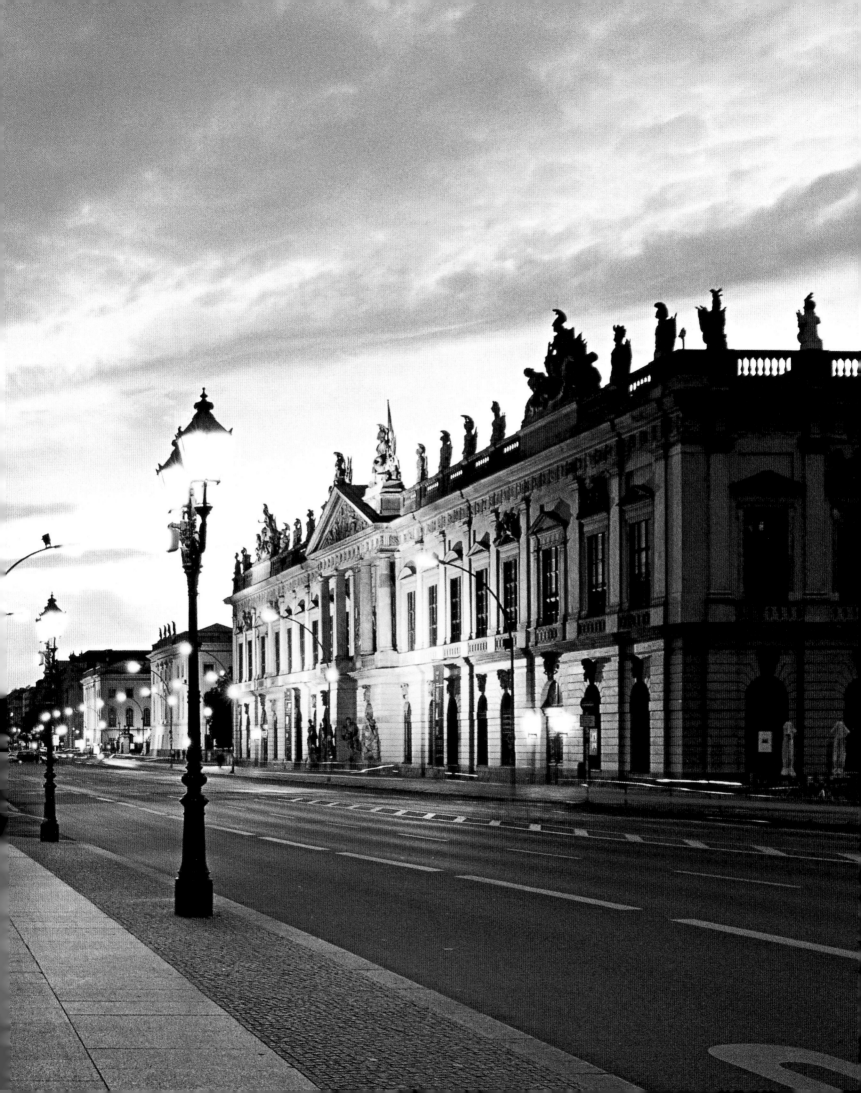

Towering high up above the world clock are the thirty floors of what was the Forum Hotel, with the spacious Alexanderplatz between them. Once the focal point of East Berlin, all attempts to revive "Alex", as it's known locally, seem to have failed – despite the famous homage paid to it by Alfred Döblin's novel Berlin Alexanderplatz.

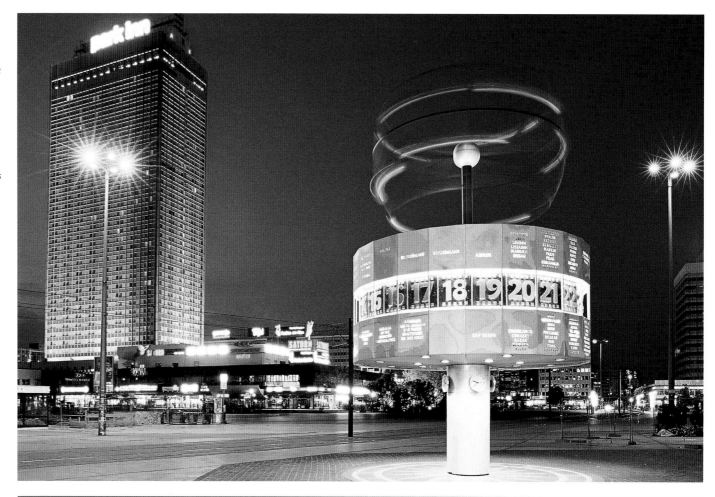

The cathedral dominates the silhouette on the River Spree. On the left is the DomAquarée with the Aquadrom, one of Berlin's hidden attractions and the largest cylindrical aquarium in the world. A glass elevator takes you on a tour of its colourful underwater wildlife.

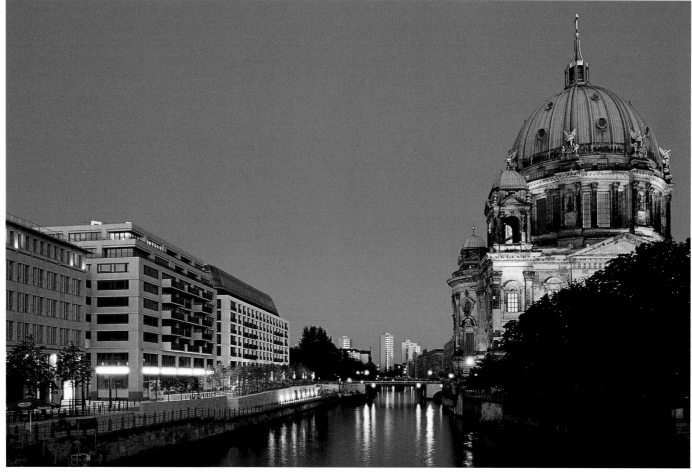

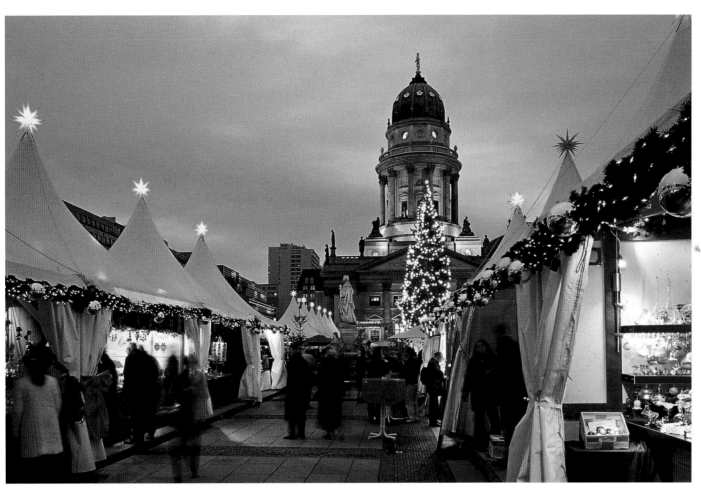

Gendarmenmarkt, the 'parlour of Berlin', provides an idyllic backdrop for the annual Christmas market in Friedrichstadt – in the heart of town yet away from the traffic.

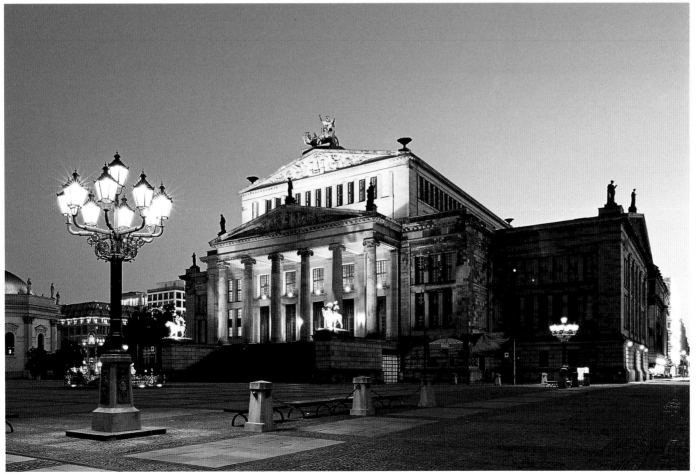

The Schauspielhaus between the French and German cathedrals on Gendarmenmarkt is heralded as one of Schinkel's most superb works, erected between 1818 and 1821 on the foundations of Langhans' national theatre from 1802. The German cathedral or Deutscher Dom is today devoted to an exhibition on the history of parliamentary democracy.

Page 28/29:
At the Bodemuseum, one of the major works of the Wilhelmine baroque, there are sculptures from antiquity to the present day on display. Next door to it is the world-famous Pergamon Museum. Berlin's Museumsinsel was made a UNESCO World Heritage Site in 1999.

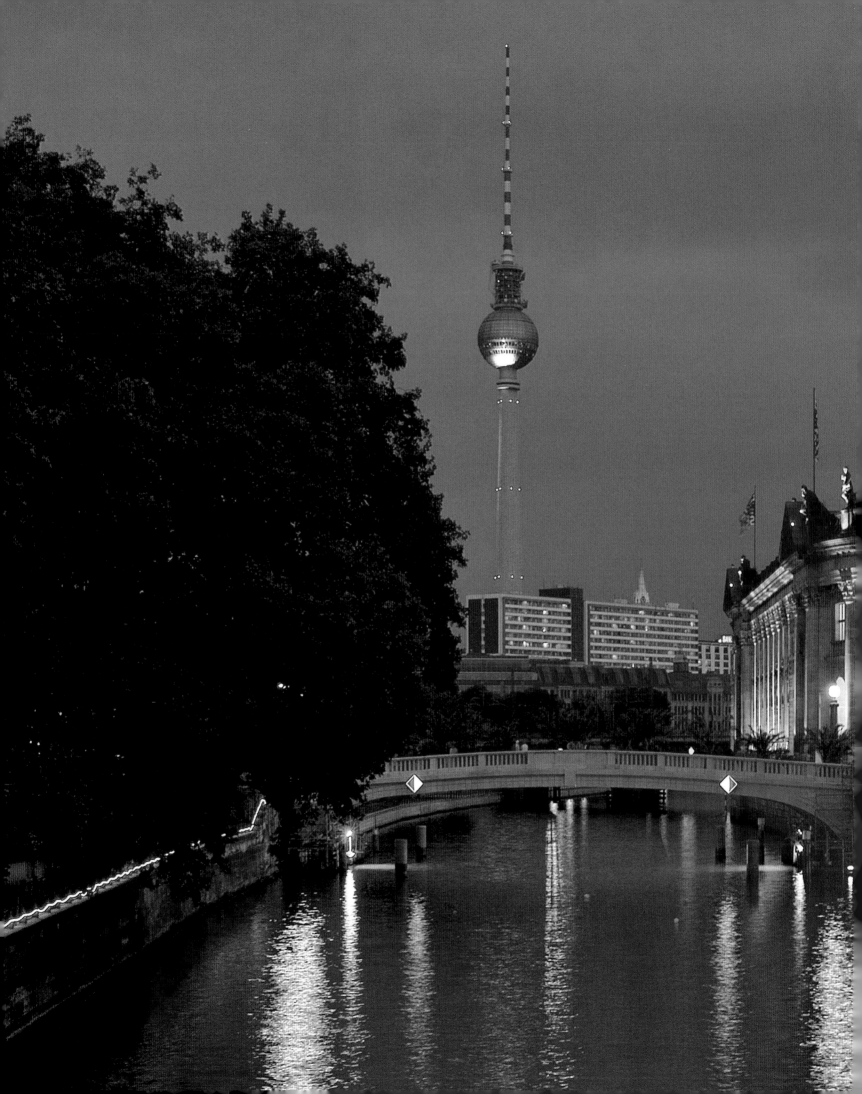

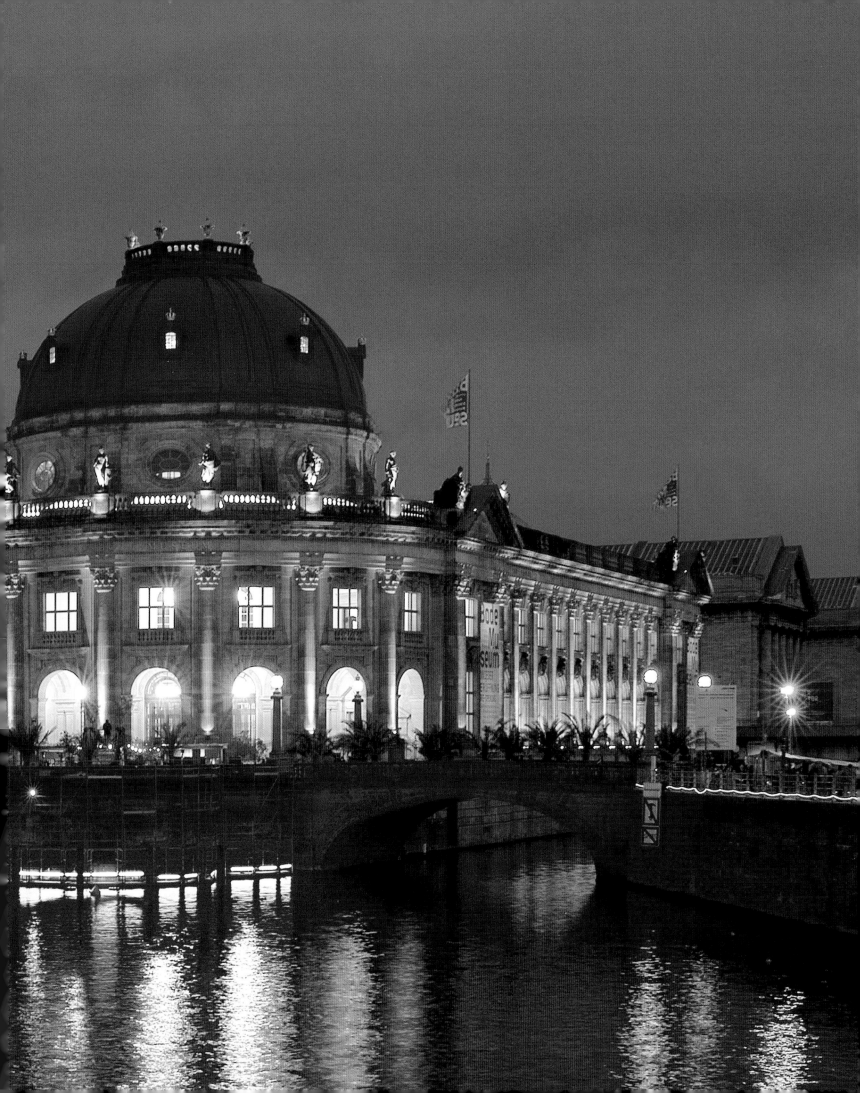

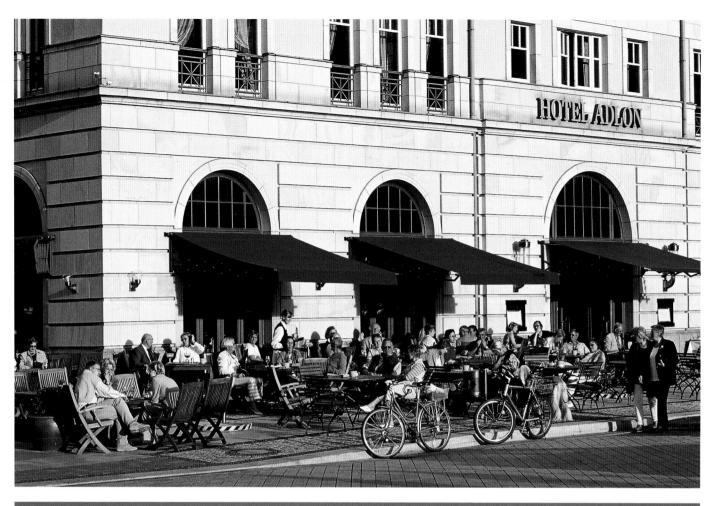

The Hotel Adlon pavement café is popular with Berliners and tourists alike – not least for its magnificent vistas of Pariser Platz and the Brandenburg Gate.

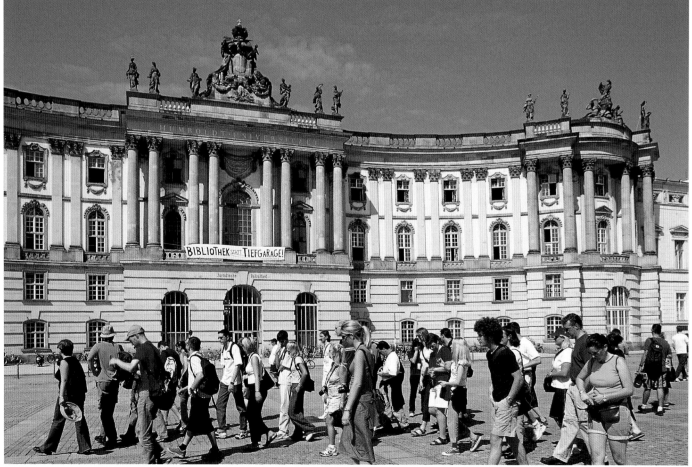

The Alte Bibliothek on Bebelplatz sports baroque forms which are unusual for Berlin. Erected in the style of Vienna's Hofburg between 1775 and 1780 its swirly baroque facade has earned it the epithet of "tallboy" (Kommode) among the locals. The square also has an underground memorial dedicated to the book burnings of the Nazi period.

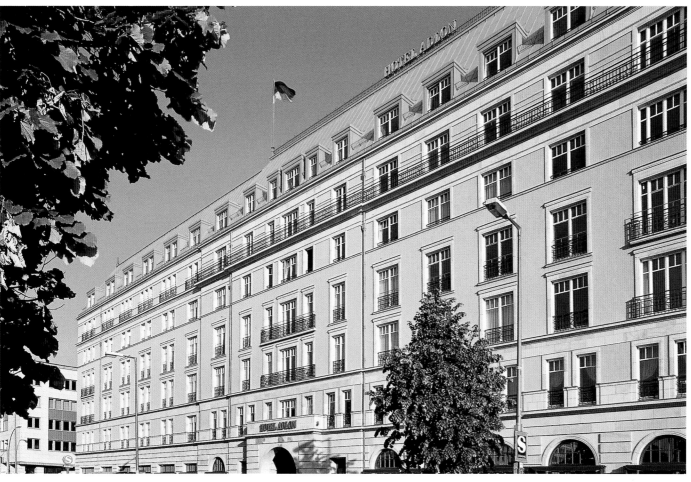

Hotel Adlon at the inter-
section of Pariser Platz
and Unter den Linden is
legendary. The new build-
ing with its mock-historic
facade is almost twice as
big as its predecessor,
stretching all the way to
Wilhelmstraße. Stars and
guests of state are among
its illustrious clientele.

Just like in the good old
days you can once again
take a leisurely stroll
under the verdant lime
trees of Unter den Linden
in the elegant centre of
Berlin. The Brandenburg
Gate at one end of it was
only open to motorised
vehicles very briefly after
the fall of the Wall,
meaning that you can
now enjoy a meal or drink
under the leafy canopy
more or less undisturbed
by the roar of city traffic.

31

The fake red brick facade of the Schinkelsche Bau-akademie has been erected in the hope of attracting investors. Schinkel's original academy was torn down in 1962 and East Germany's foreign ministry put up in its place. This was removed in 1995; the show building site currently stages various exhibitions and events.

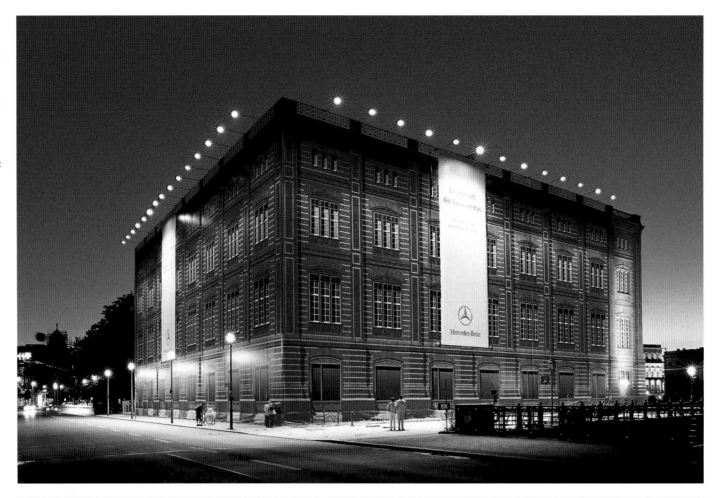

The Akademie der Künste, Berlin's art academy, has been returned to its original site on Pariser Platz. Here budding artists can take a break from classes and exchange ideas while lounging on classic furniture. The club area with its famous Le Corbusier sofas and armchairs is reserved for members and guests of the academy alone – as is the breathtaking view of the Brandenburg Gate from this floor of the building.

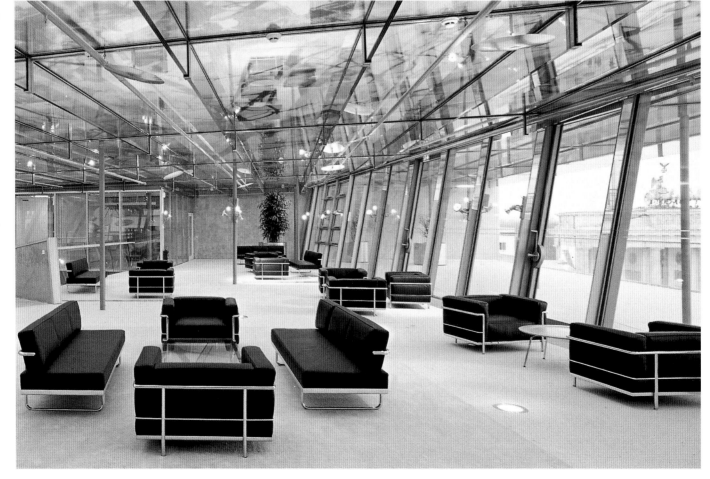

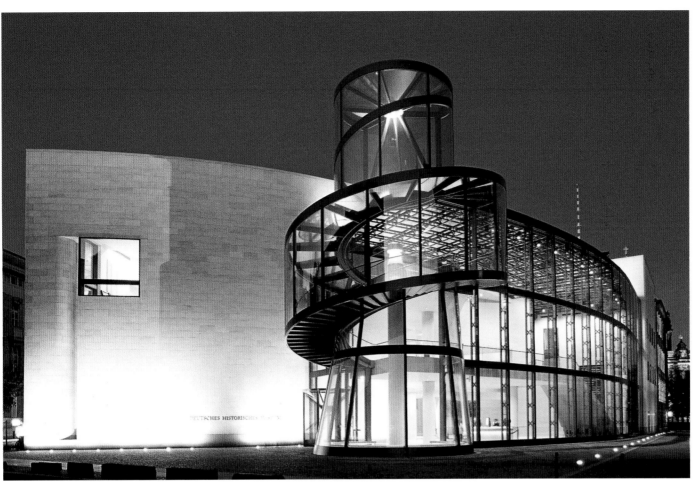

Behind the baroque arsenal at the beginning of Unter den Linden are the new exhibition rooms belonging to the Deutsches Historisches Museum. They were designed by the renowned Chinese-American architect Ieoh Ming Pei, whose glass spiral staircase is famous far and wide.

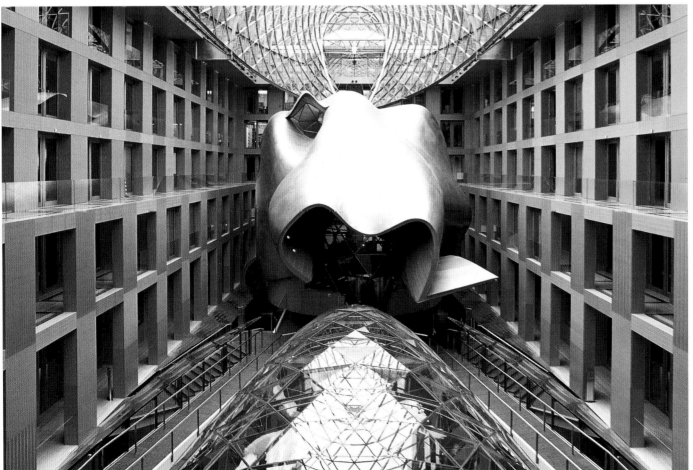

In designing the facade of the DZ-Bank on Pariser Platz Californian star architect Frank O Gehry carefully followed instructions to produce a building with evenly distributed sections of stone and windows. He was allowed to exercise a freer hand in the design of the main air well, placing an original sculpture of a (flying) fish at its centre.

Page 34/35:
The Holocaust Memorial designed by Peter Eisenman in the former ministry gardens was opened in 2005. In his own words the 2,711 stone blocks are supposed to imitate a "rippling field of grain". The visitors' centre underneath the concrete stelae has an exhibition on the Holocaust.

33

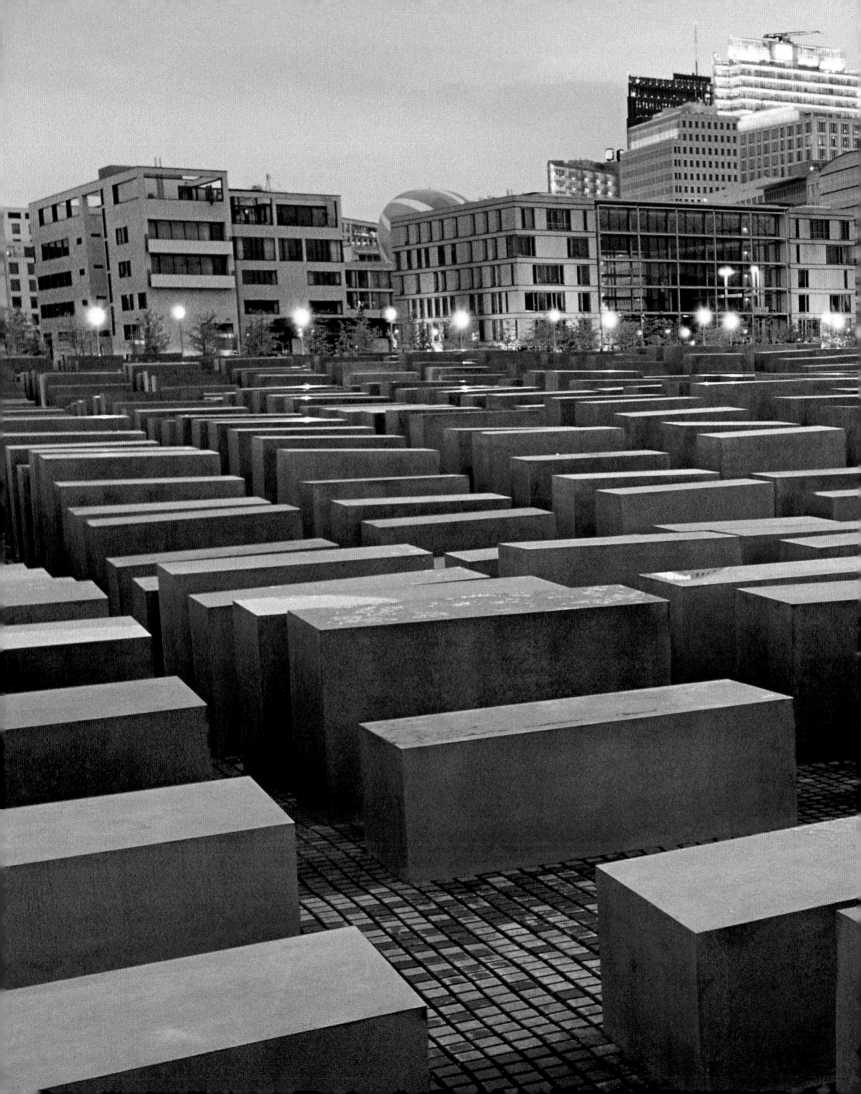

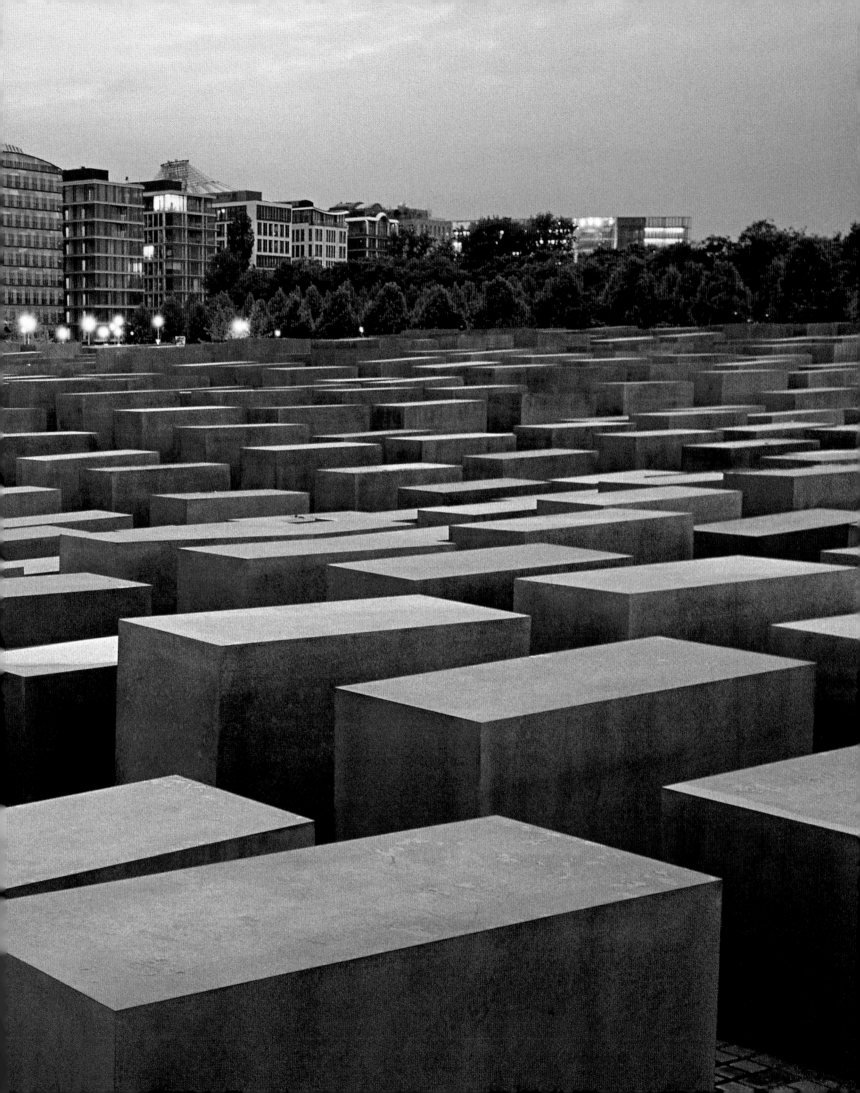

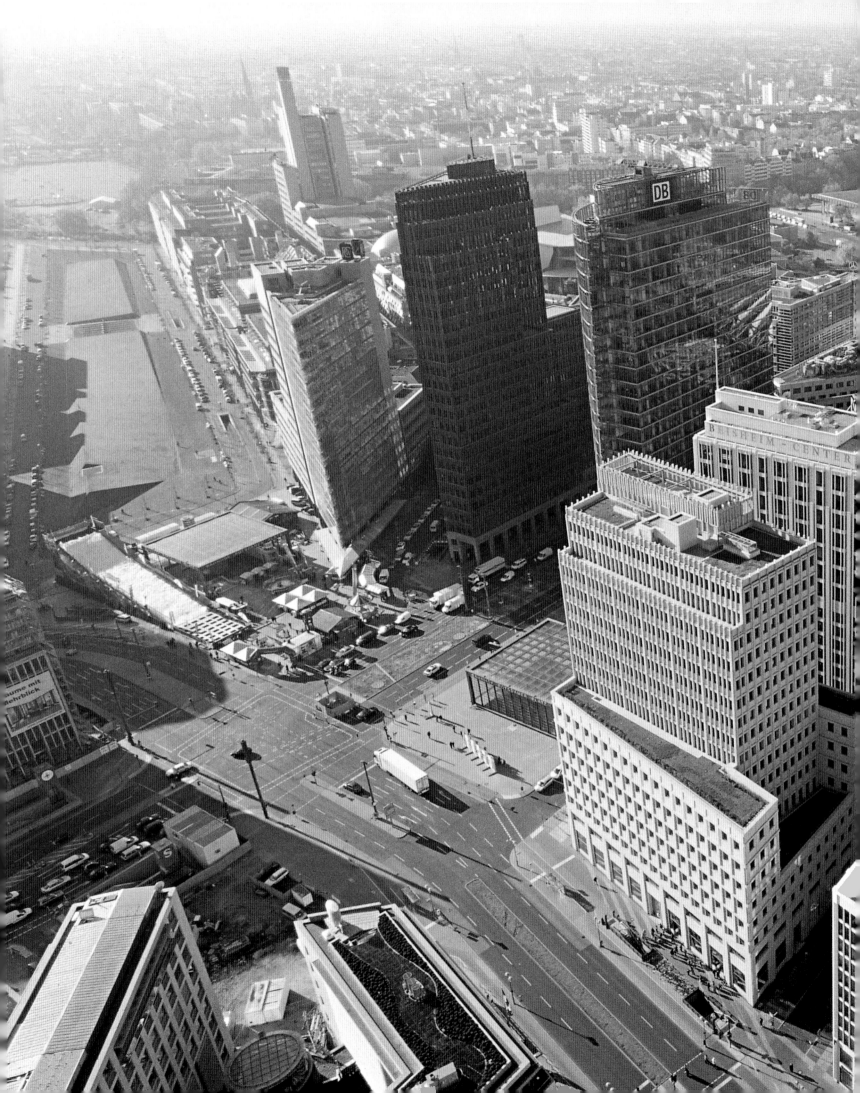

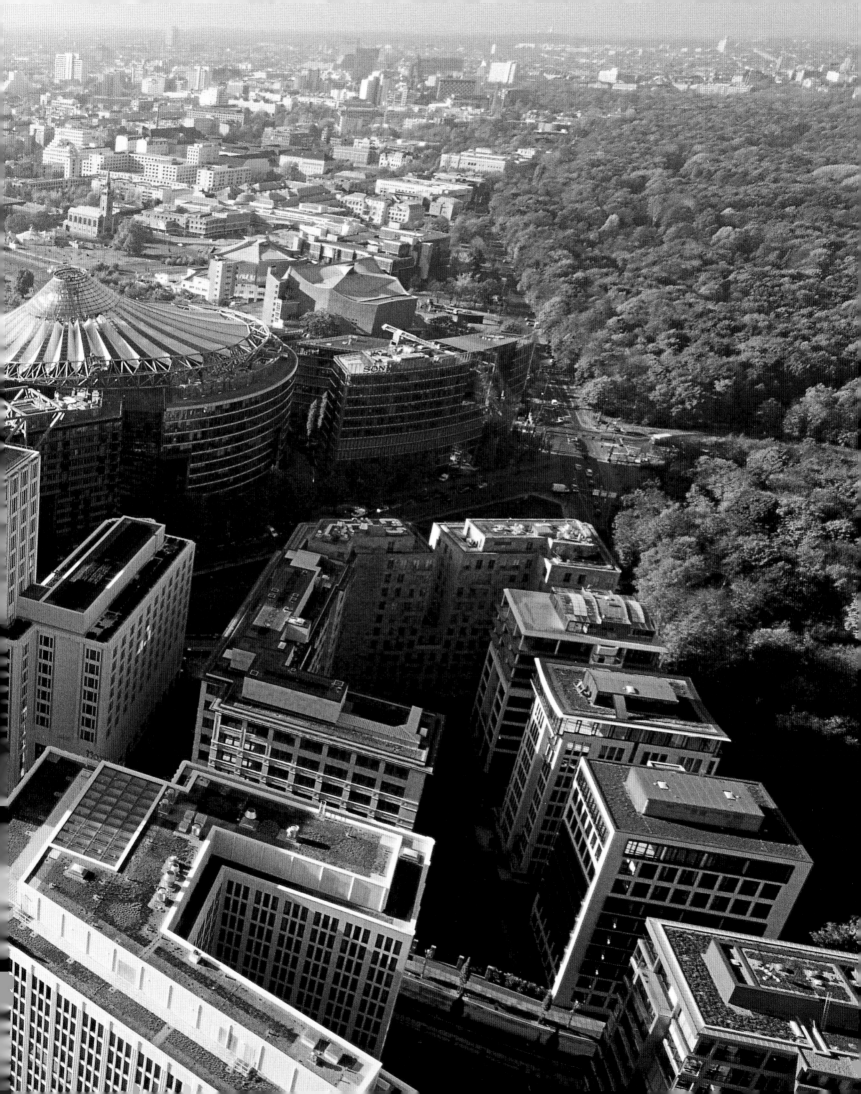

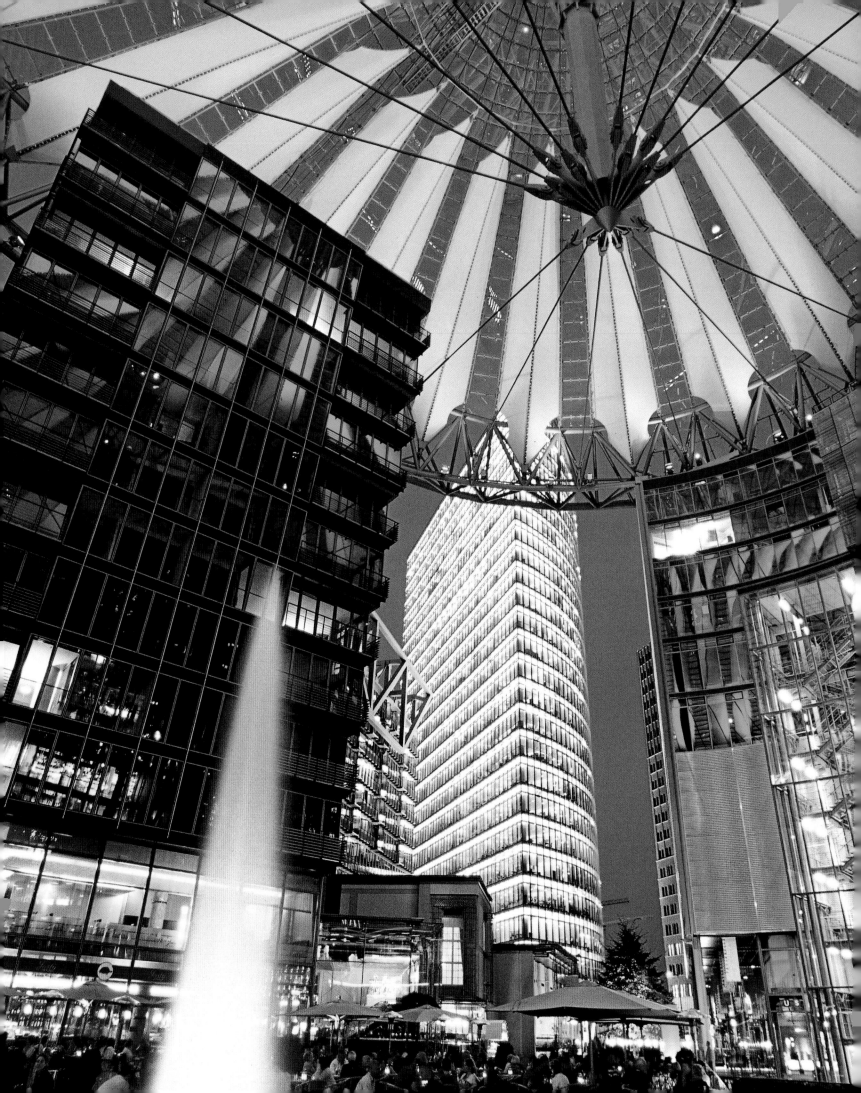

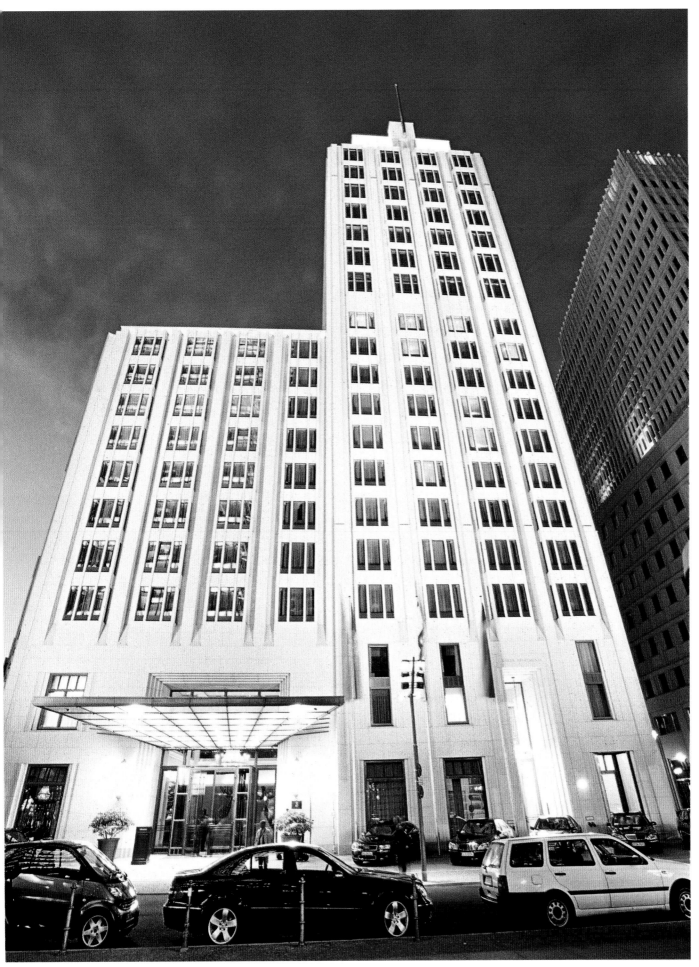

Page 36/37:
The various high-rises on Potsdamer Platz pierce the sky like urban mountains in the midst of an otherwise flat city landscape. From here it's just a stone's throw to Tiergarten, the huge park in the middle of Berlin offering respite from the hustle and bustle of city life.

Left page:
The Daimler complex on Potsdamer Platz seems small and cosy compared to the cosmopolitan sprawl of the Sony Center. Its spacious interior is an orgy of cafés, restaurants and shops and also gives access to the film museum with its impressive hall of mirrors.

The third largest ensemble on Potsdamer Platz after Daimler and Sony is the Beisheim Center. Above the luxury Ritz-Carlton Hotel there are a number of exclusive city apartments which boast "accommodation with room service" – a setup as yet unique to Germany.

The Friedrichstadtpassage is a completely new construction. The three blocks Q205, Q206 and Q207 between the Französische Straße and Mohrenstraße are joined underground. Quartier 206 with its expressive facade, illuminated by hundreds of bands of light set into its surface, was built by IM Pei, among others.

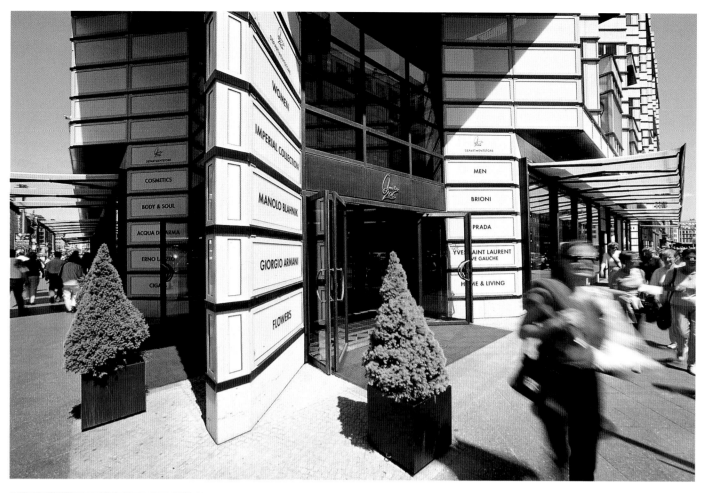

The most exclusive wares can be found at Quartier 206, the middle of the three blocks. Not only the facade is reminiscent of Art Deco; the elaborate Carrara marble flooring inside is also impressively retro. Quartier 206 is also a great place to take a break from shopping – although the temptation to buy is hard to resist…

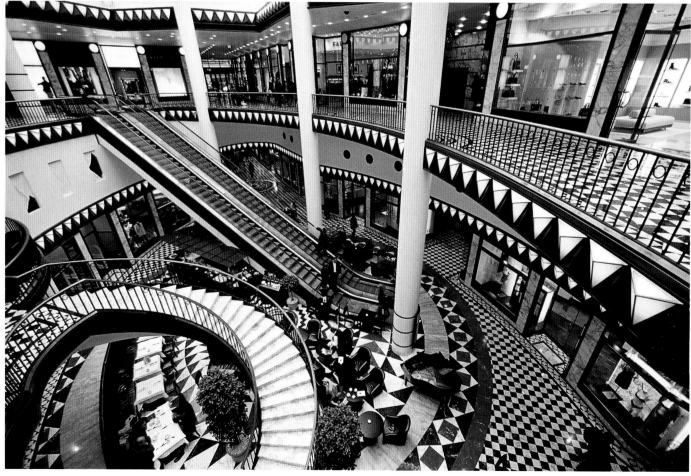

The Rosenhöfe next door to the Hackesche Höfe seem a lot more modern than their neighbours. Other unusual courtyards in Berlin include the Sophie-Gips-Höfe and the Heckmannhöfe, both in the suburbs of Spandau.

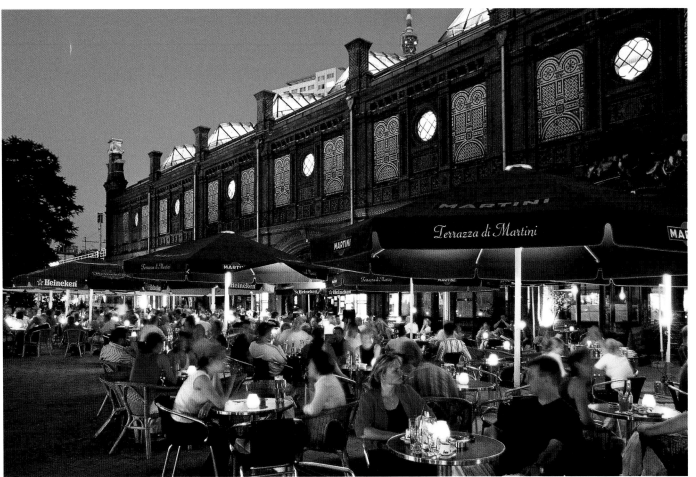

The mock-historic Hackescher Markt station still operates in the original building from 1882. Cafés, restaurants and shops have set up underneath the railway arches, with plenty of outdoor chairs and tables from whence you can observe the goings-on over a cup of coffee or a beer.

43

For ten years now, each Whitsun Kreuzberg has staged its vibrant Karneval der Kulturen. Berlin has the highest number of foreign residents in Germany (ca. 450,000); the holiday festival is the capital's way of presenting its cultural diversity to the world at large.

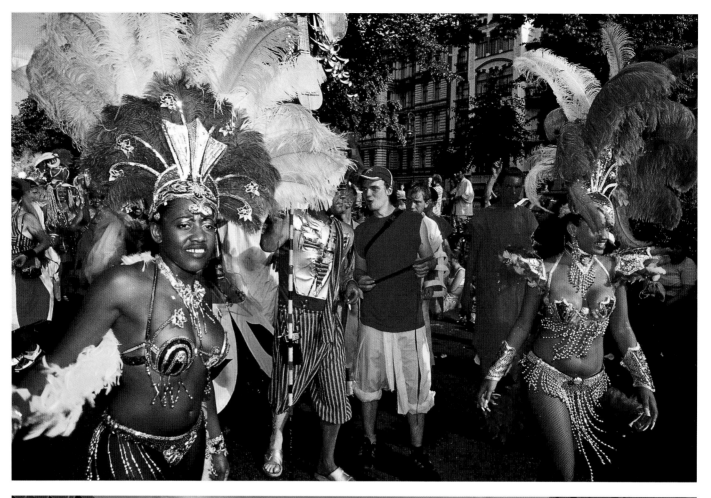

In 1979, ten years after the police raid on the gay Stonewall Inn bar in New York, Berlin held its first Christopher Street Day. Part demo, part party, this event has been ceremoniously opened in the past few years by Berlin's mayor Klaus Wowereit, himself a member of the gay community.

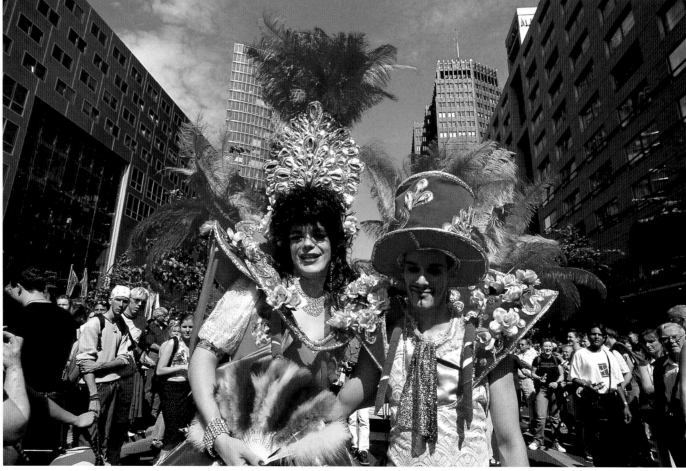

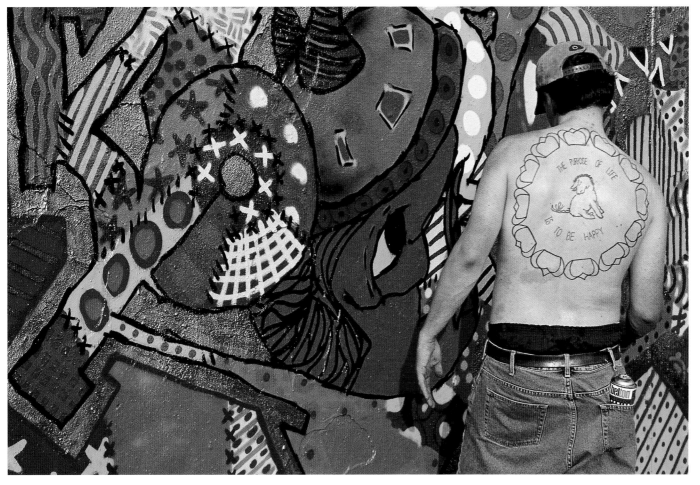

Graffiti has long been an accepted art form – and not only at the famous East Side Gallery in Berlin. In the Mauerpark, the old East German death strip which has been turned into a peaceful park, the remains of the Berlin Wall are regularly resprayed with new murals and motifs.

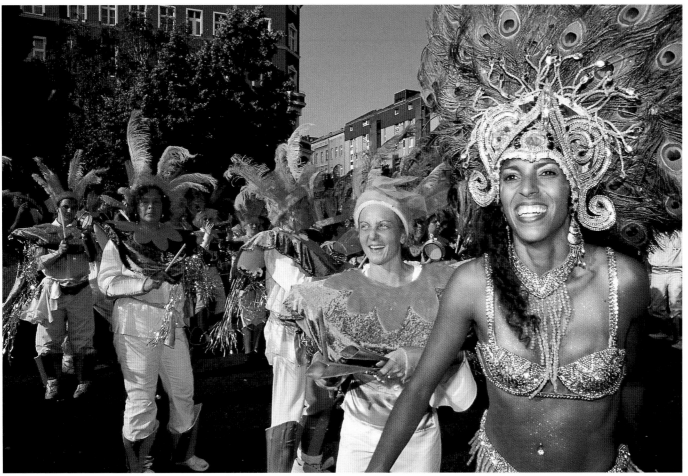

The Karneval der Kulturen consists of a parade through Kreuzberg and several days of partying on Blücherplatz. The colourful spectacle pulls the crowds year after year, with up to two million flocking to the German capital from all over the world.

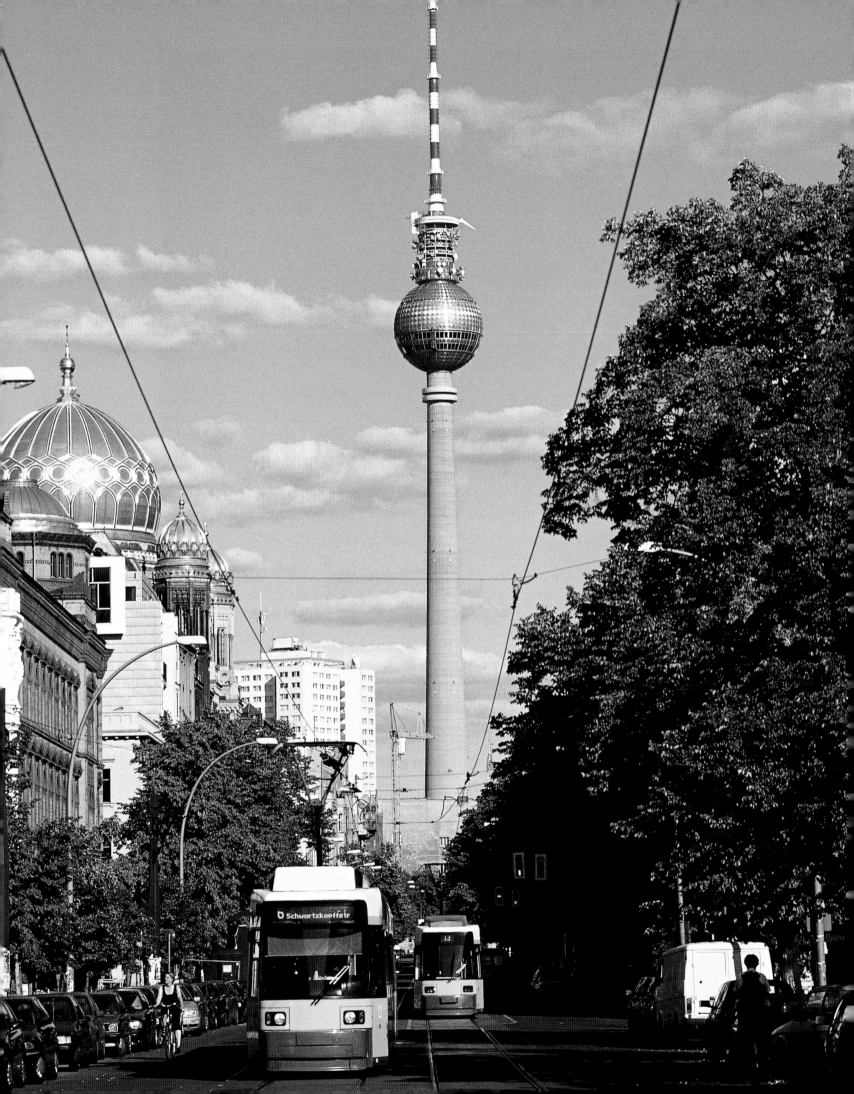

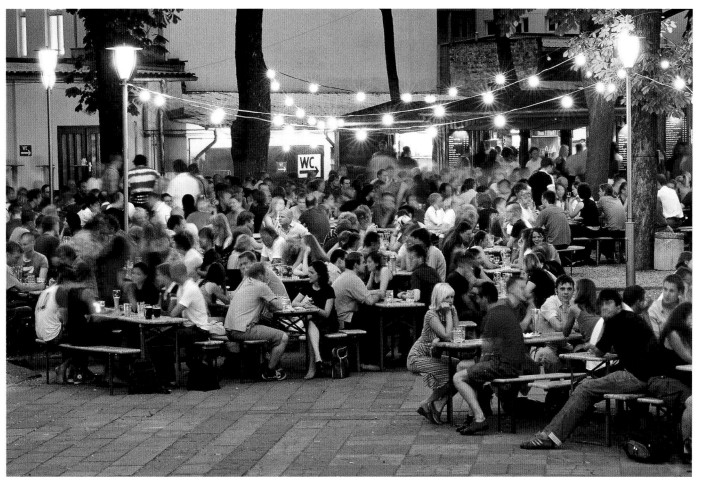

Left page:
Oranienburger Straße in Berlin-Mitte is worth a visit on several counts. There's the new Jewish synagogue with its gilt dome, for example, the alternative and ruinous Tacheles arts centre and Monbijou Park with its grand views of the television tower on Alexanderplatz.

Prater on Kastanienallee in the Prenzlauer Berg district has the oldest beer garden in Berlin. In its long, turbulent history its walls have resounded to the strains of dance music, political cabaret and marching bands. In 1946 it provided the Berliner Volksbühne with a permanent venue. The hall is still used by the ensemble.

Kollwitzplatz in Prenzlauer Berg was a popular meeting place during Berlin's East German era. This hasn't changed; the triangle of land, named after Käthe Kollwitz, is now lined with pubs and cafés, as is the Wasserturmplatz nearby. The latter also boasts a Russian restaurant.

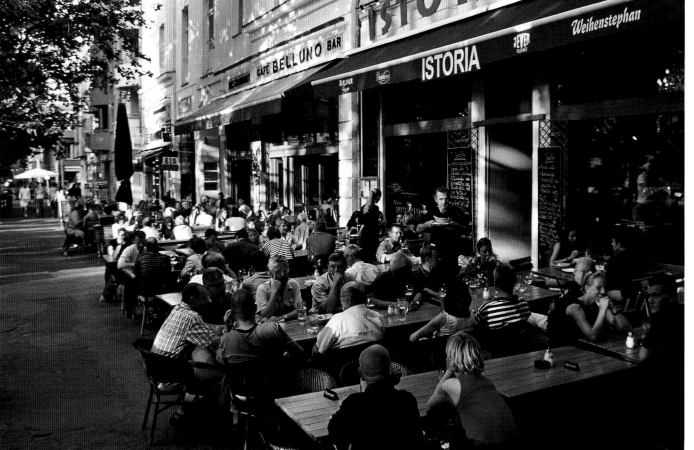

Page 48/49:
The square in front of the German chancellery has the air of an Expressionist stage set. The country's new centre of power lies on a bend in the River Spree at the heart of the government quarter and only a short distance from the Reichstag and Brandenburg Gate.

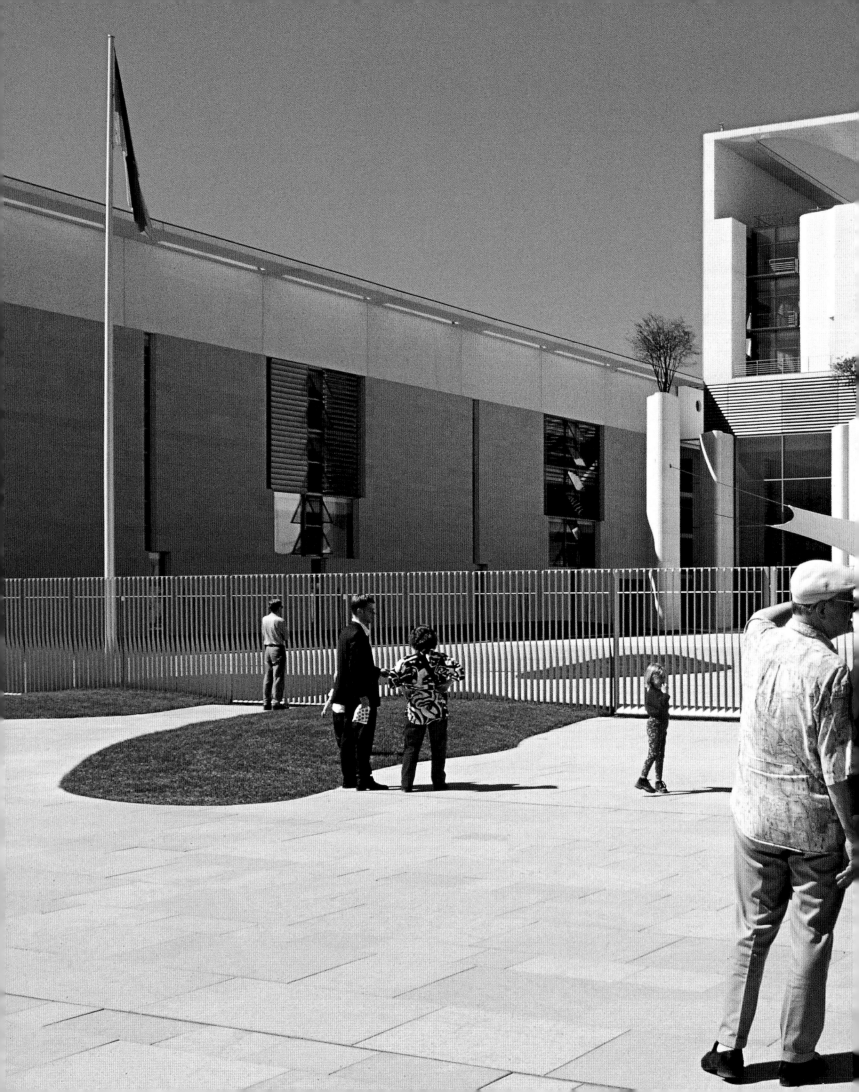

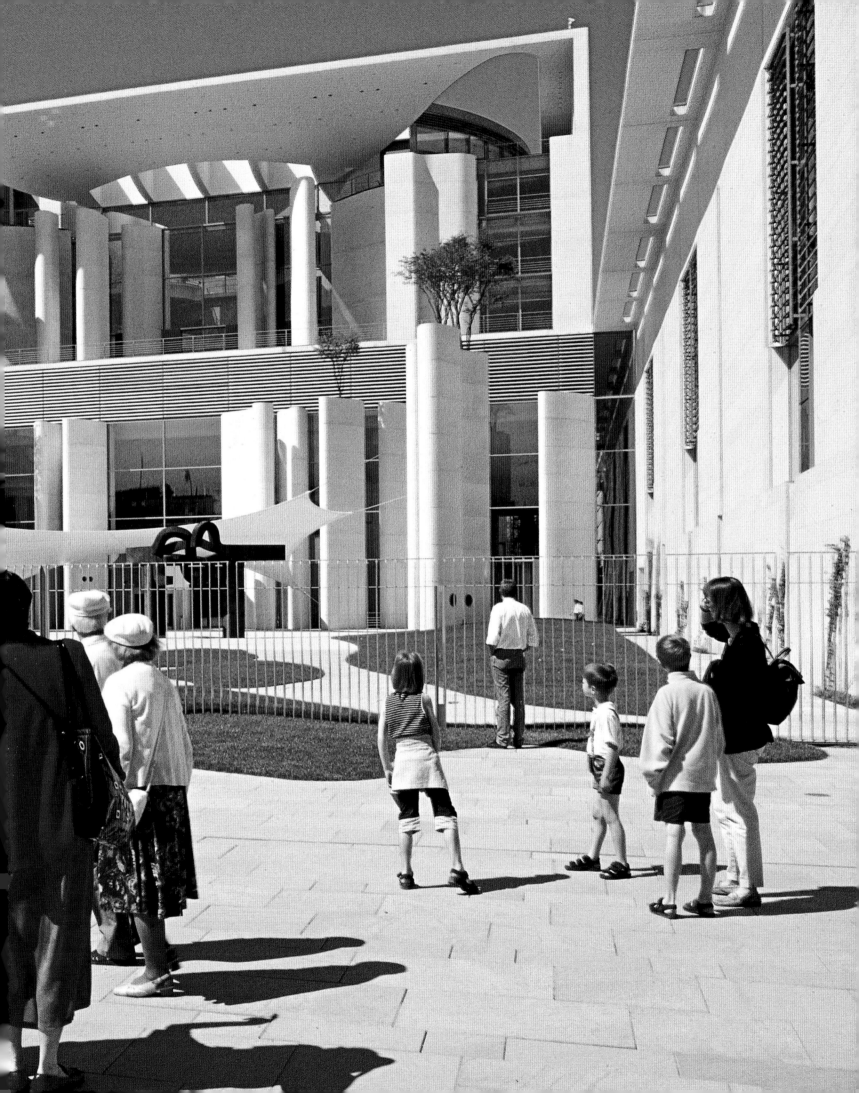

The parliamentary library in the Marie-Elisabeth-Lüders-Haus is the third largest in the world after Washington and Tokyo. A two-level pedestrian bridge links the Lüders building with the Löbe-Haus on the opposite bank of the Spree.

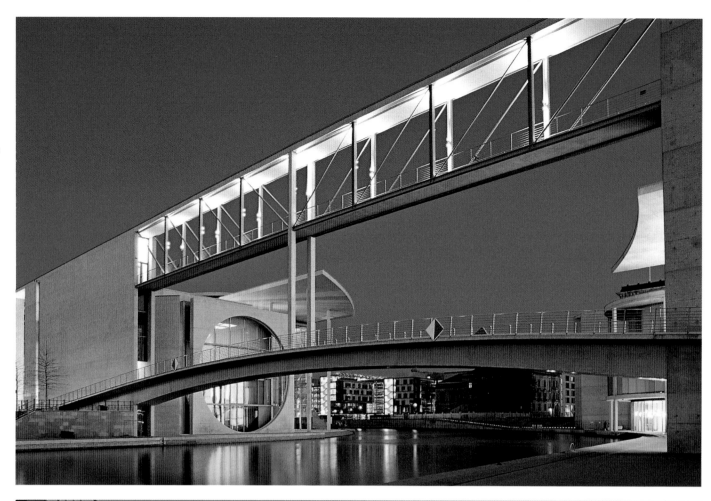

The verdant chancellery garden on the other side of the Spree comes complete with a helicopter landing pad. On arrival the chancellor and her state guests can be driven straight to the chancellery across the Nordbrücke.

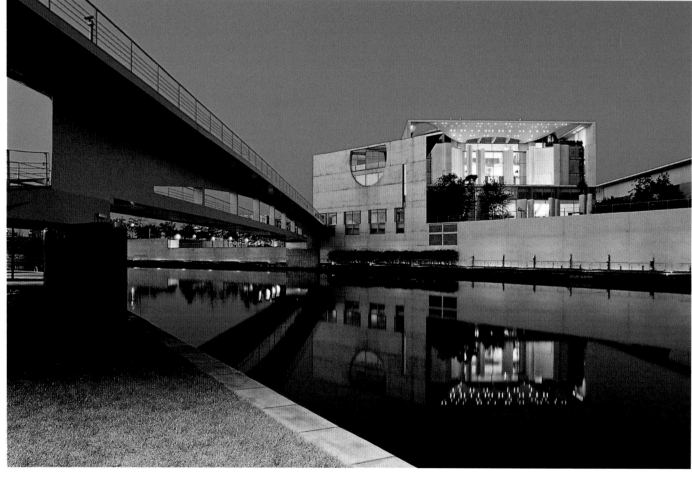

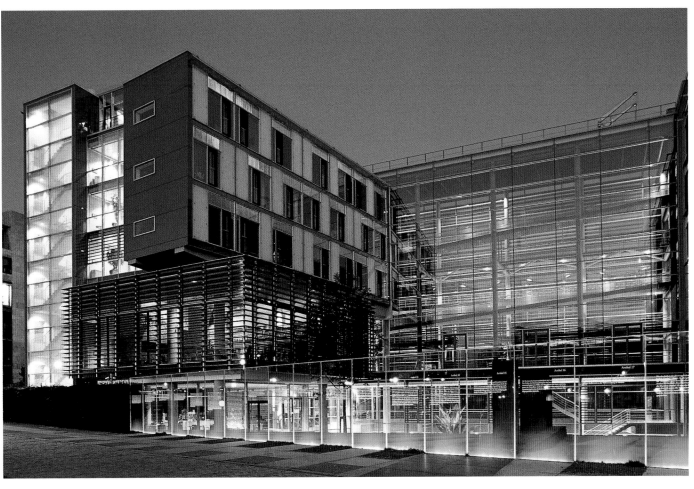

Three historic buildings have been integrated into the elaborate Jakob-Kaiser-Haus complex, among them Paul Wallot's former palace of the president of the Reichstag. The entire ensemble has ca. 2,000 rooms.

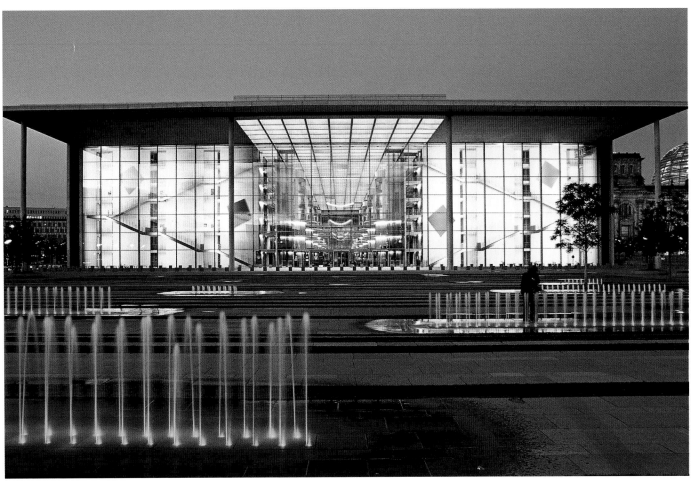

The Paul-Löbe-Haus is also part of the Berlin parliamentary setup, with offices, meeting rooms and a restaurant for visitors. The building lines the other side of the chancellery square.

Without doubt the most popular 'new building' in the Berlin government quarter is the dome inserted into the roof of the Reichstag. Huge panes of glass protect visitors from the elements while providing panoramic views of the capital.

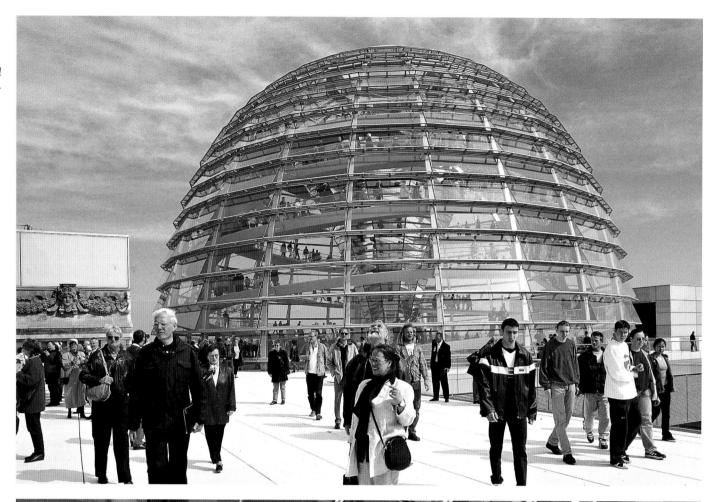

The viewing platform at the top of the dome is open to the sky, letting in sun, light and air. It's 40 metres (130 feet) up above the Reichstag roof which with the dome has to bear the weight of 800 metric tons of steel and glass.

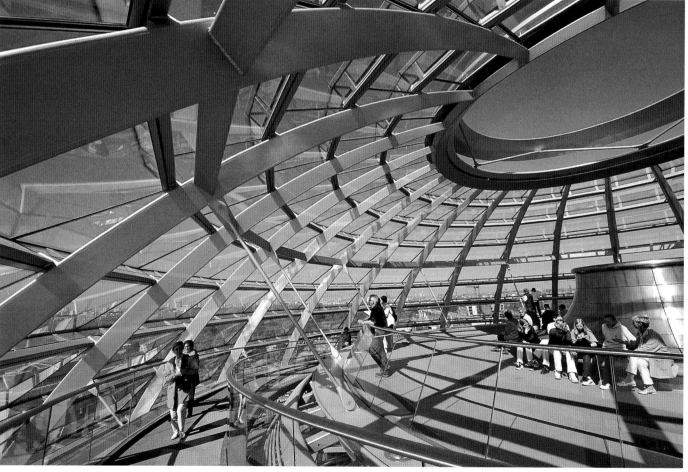

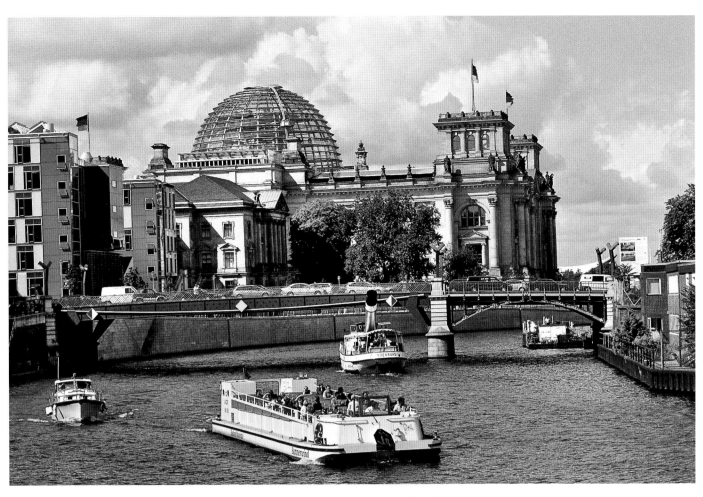

Seen from the Spree the Reichstag dome appears fragile, filigree even. Paul Wallot's original building was re-erected by Paul GR Baumgarten between 1961 and 1973. During the 1990s one of Europe's top high-tech architects, Lord Norman Foster, won the competition to refurbish the interior and create "something new from something old".

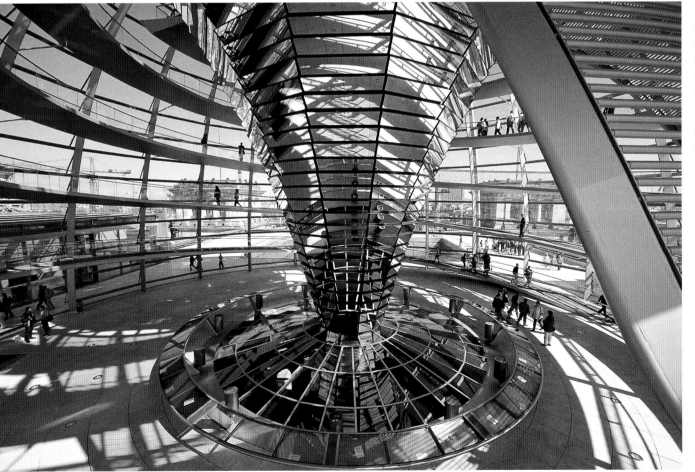

The enormous mirrored cylinder in the middle of the dome feeds light down into the plenary chamber below. While spiralling up the ramp to the top of the dome you can check whether the politicians below are having a bad hair day or not ...

Page 54/55:
The Kulturforum between Tiergarten, Landwehrkanal and Potsdamer Platz is where many of the museums run by the Stiftung Preußischer Kulturbesitz are sited. Hans Bernhard Scharouns was responsible for the buildings of the Philharmonie (1960–1963), the state library (1966–1978) and the Neue Nationalgalerie (1965–1968).

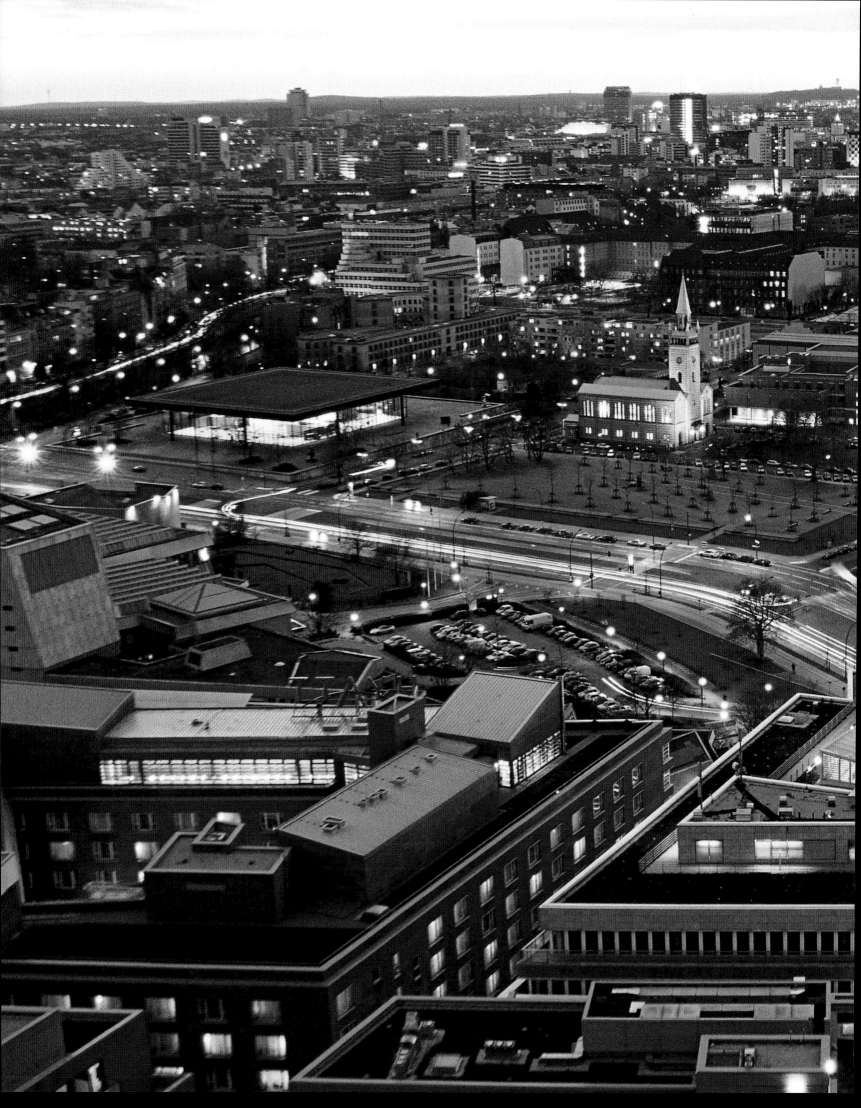

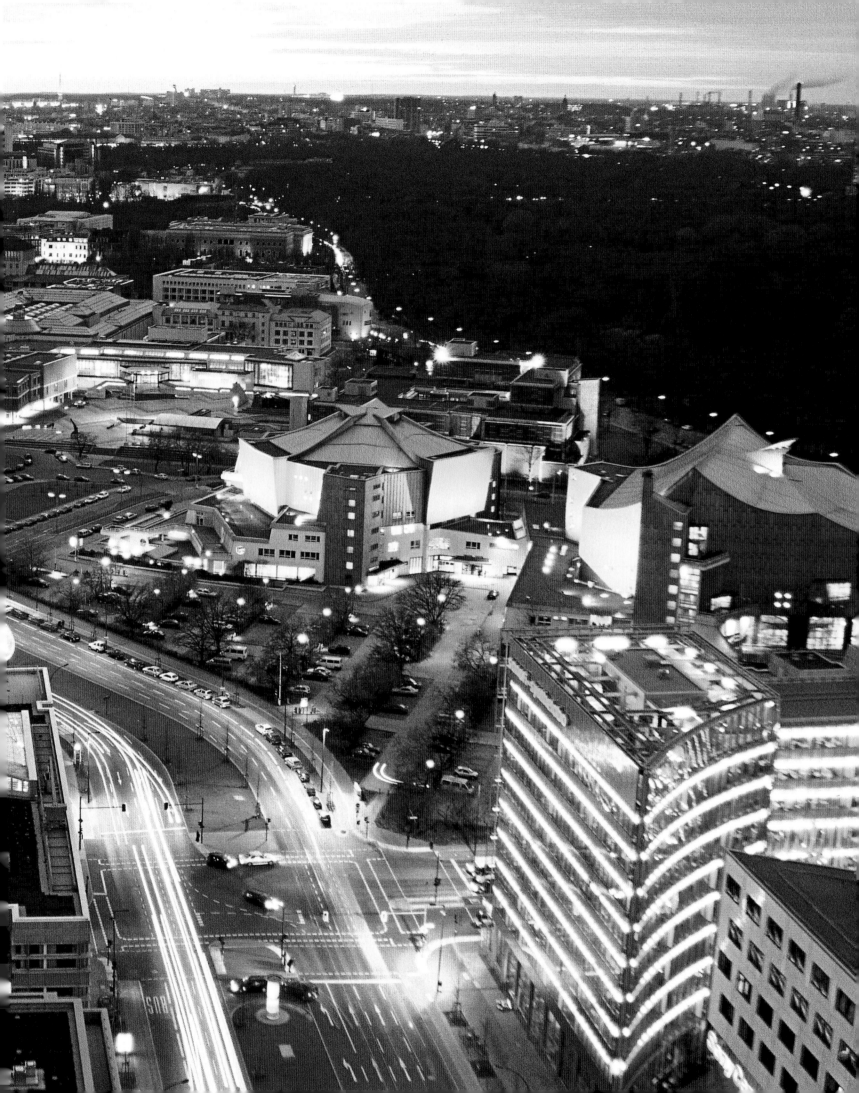

The oldest passenger railway station in Berlin, Hamburger Bahnhof, was turned into a museum as early as in 1906. When in 1996 the station was revamped as the Museum für Gegenwart the new exhibits by such artists of renown as Andy Warhol and Joseph Beuys soon ensured that it became one of the top museums of contemporary art in Europe.

With the opening of the Gemäldegalerie in 1998 the reformation of the Kulturforum was complete. The collections of the Great Elector and Frederick the Great make up the basis of the museum's exhibits. The gallery provides an excellent survey of European art up until the end of the 19th century.

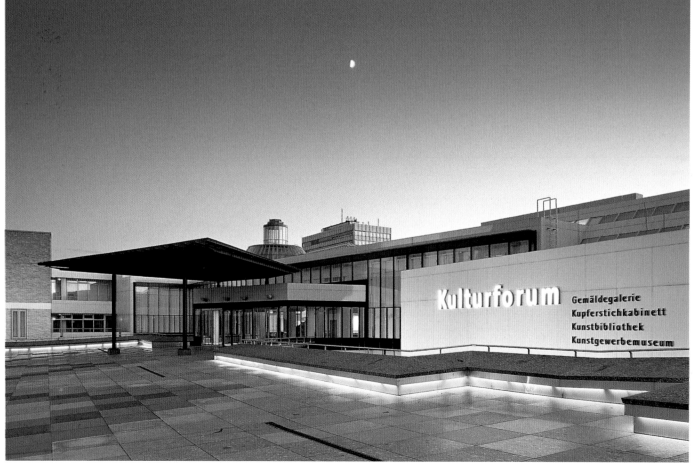

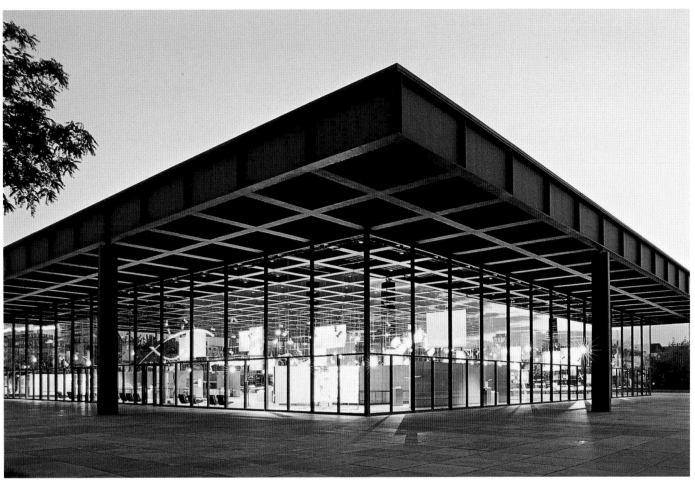

The Mies-van-der-Rohe-Bau is a classic of modern architecture. Its unusual form is not the only thing which makes it the subject of repeated debate, however; the exhibitions held in its Neue National-galerie are also often hotly disputed. The biggest draw in recent years was the spectacular MoMA exhibition.

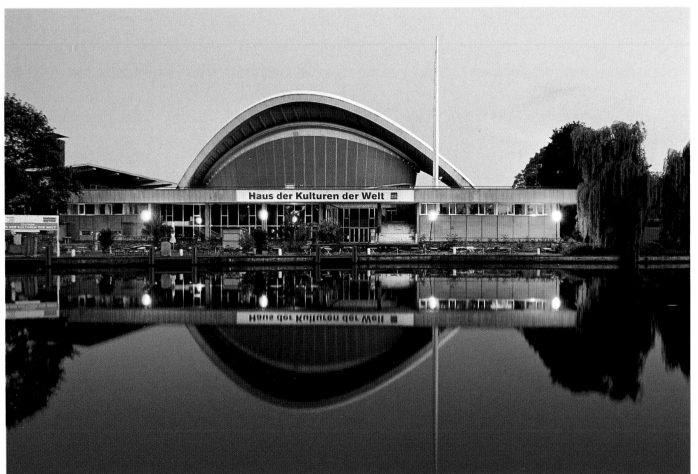

The present Haus der Kulturen der Welt (House of World Culture) is known locally as the "pregnant oyster". The roof of the congress hall, opened in 1957, collapsed in 1980. Today the building is a venue for exhibitions and popular ethnomusic concerts.

This facade near Bergmannstraße in Kreuzberg is typical of the crowded housing of the late 19th century. The buildings facing the street had balconies which let in light and air; the apartments overlooking the dark, cramped back yards were much more dismal.

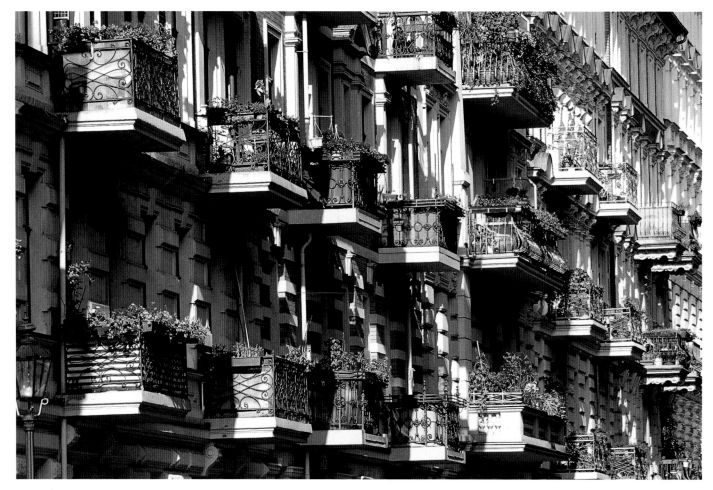

This inner courtyard on Solmsstraße in Kreuzberg has been turned into the Kunstwerkhof, an art studio which functions true to the old Berlin tradition of living and working in the same restricted space.

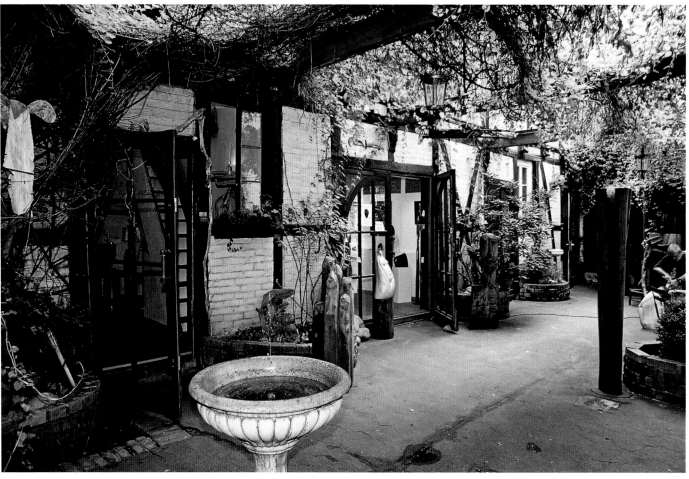

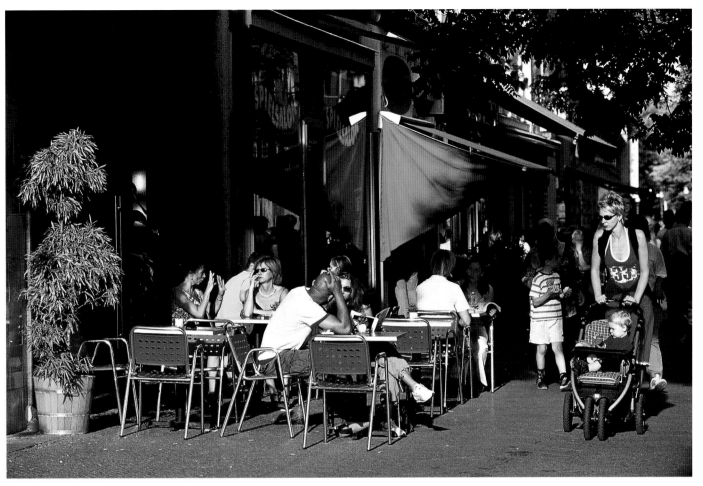

Living life outdoors is important to Berlin's city dwellers. This café on Bergmannstraße in Kreuzberg, not far from the Marheineke market hall, is one of many inner city localities where people take break from shopping, sit down and read a book or the paper or meet up with friends for a drink and a chat.

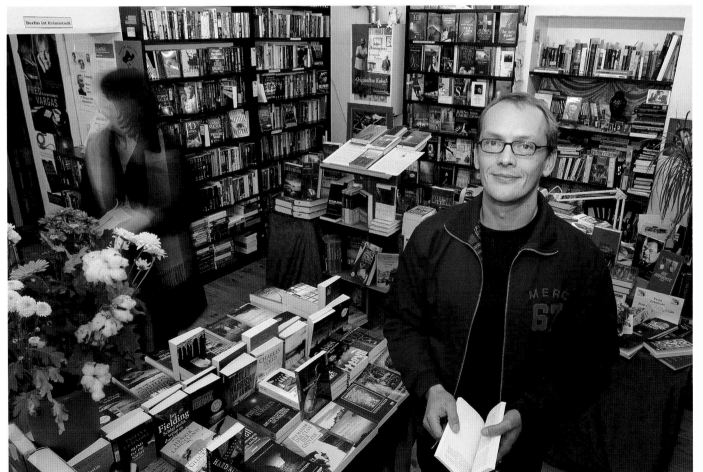

Christian Koch's Hammett bookshop specialises in detective stories and thrillers. He has ca. 2,500 German and around 1,000 English titles in stock. He also has plenty of second-hand books on sale.

Page 60/61:
For several years now traffic has again trundled across the Oberbaumbrücke between Kreuzberg and Friedrichshain, including the famous Linie 1 underground train. For many years the distinctive brick neo-Gothic structure from 1896 could only be traversed on foot by people crossing the border into East Berlin and the GDR.

59

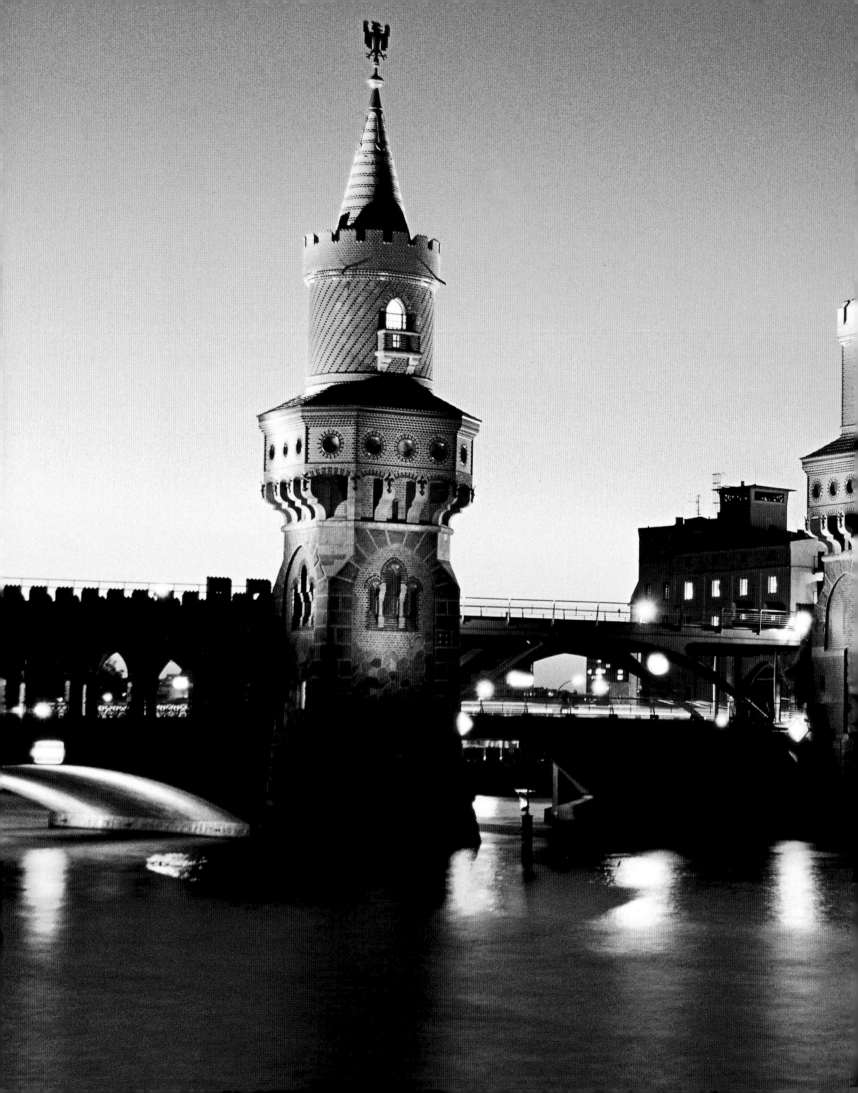

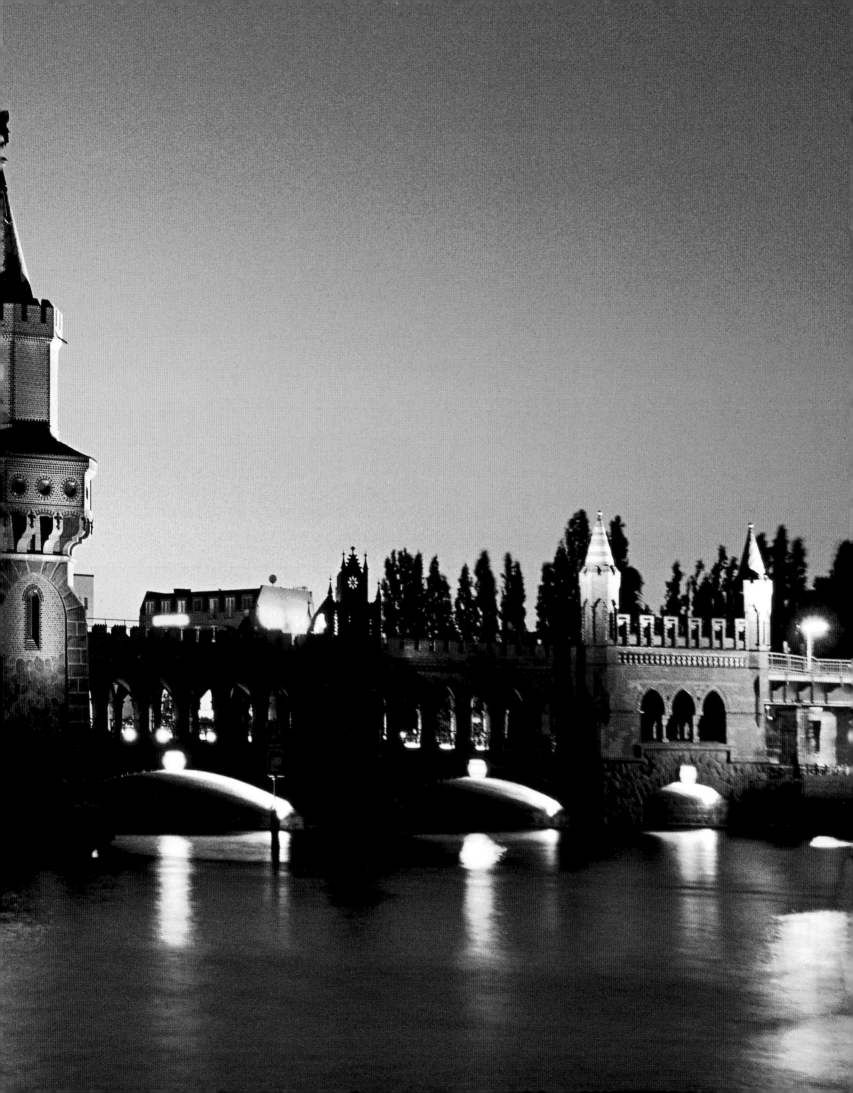

When the lifeguard goes off duty at midnight the water nymphs switch from bikini to little black number and head off for a night on the town. The Badeschiff, depicted here, is a converted barge where you can swim while enjoying the magnificent city panorama. Its clean and warm waters 'in' the Spree have been open to the public since 2004.

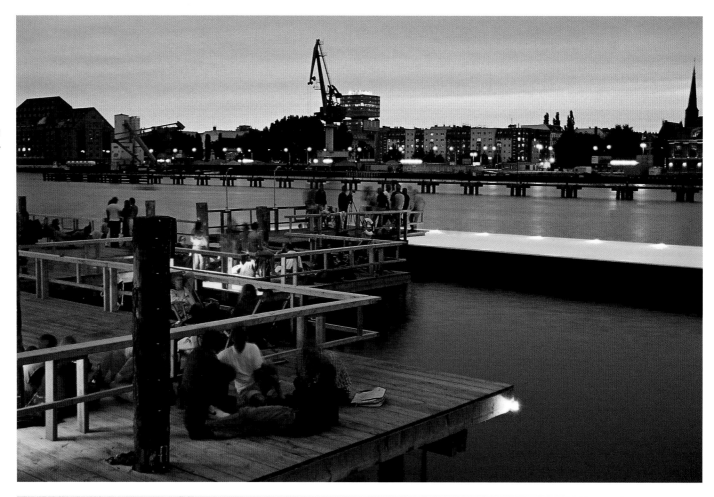

The owners of Strandbar Mitte, the first 'beach bar' in Berlin, have recently opened the Oststrand at the back of the East Side Gallery on an old barge which has been converted into a floating restaurant on the River Spree. While dining you can take in grand views of the Badeschiff and Oberbaumbrücke at the Osthafen.

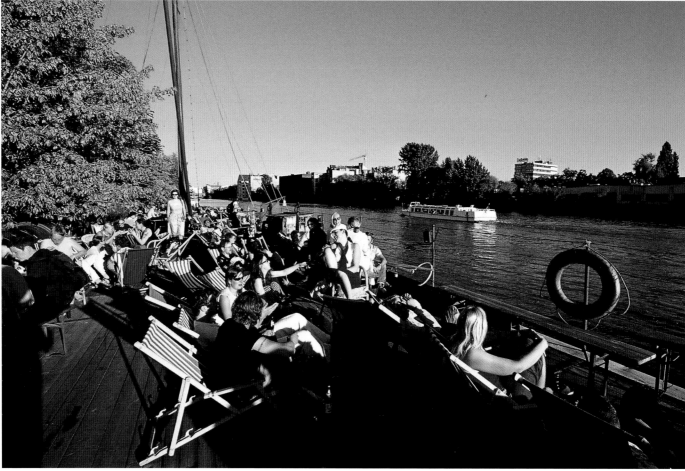

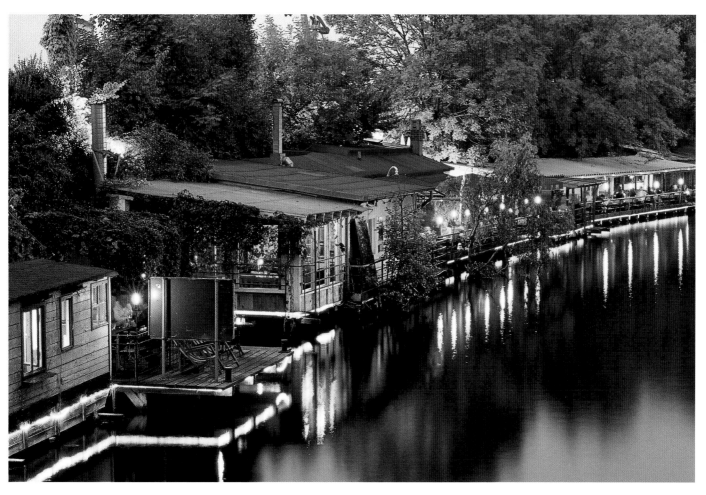

Once a boat hire on the former border between Treptow and Kreuzberg, the brightly lit Frei-schwimmer pub on the flood channels of the Spree serves international cuisine and potent cock-tails opposite the equally hip Club der Visionäre.

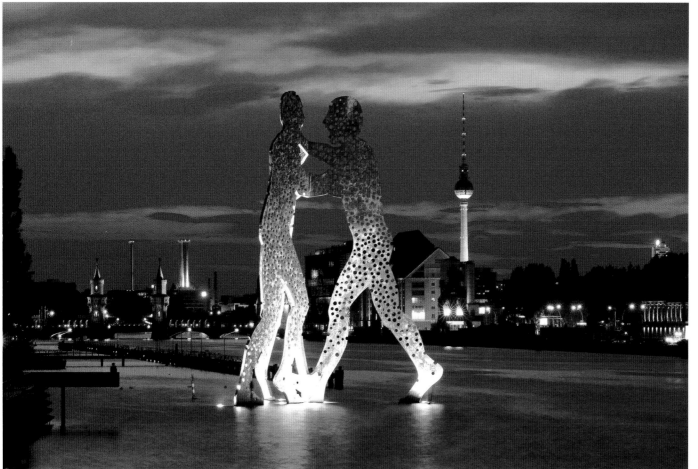

Visible for miles around and riddled with holes, American sculptor Jonathan Borofsky's Molecule Men walk on the waters of the Spree. The metal sculptures were commissioned by the Allianz group and positioned outside their new office block at the Osthafen.

Page 64/65:
Branches of all the major chain stores battle for custom on the elongated Tauentzienstraße in the west of Berlin. At Christ-mas 1,200 sets of fairy lights, 20,000 metres (over 6,500 feet) of cable, an enormous Father Christmas and 15 reindeer help to create a festive atmosphere, with the Gedächtniskirche just visible beyond the glare in the background.

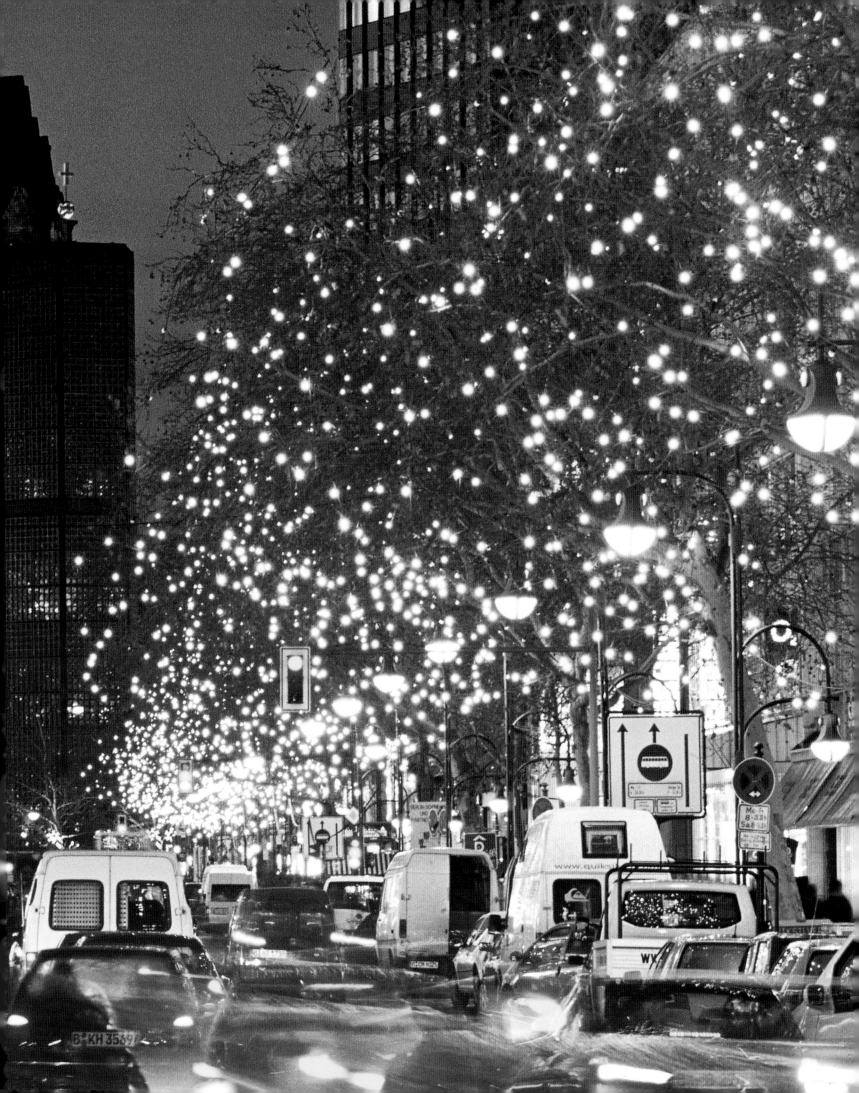

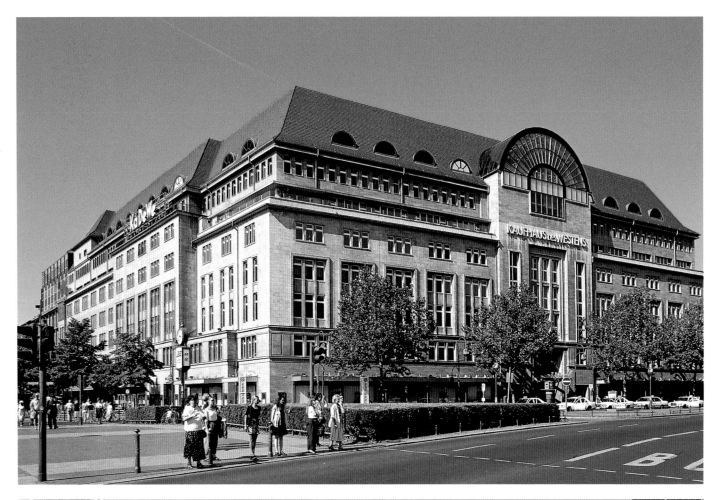

KaDeWe (Kaufhaus des Westens) was opened in 1907. Despite the later materialisation of retail havens such as the Friedrichstadtpassage the biggest department store on the Continent is number one with Berliners and visitors alike. Its famous food hall is undoubtedly one of the reasons for its huge popularity.

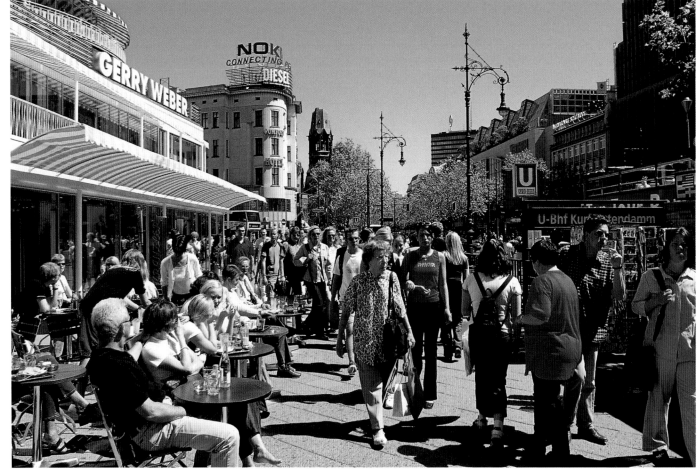

Kurfürstendamm was the epitome of pulsating city life in West Berlin. Bismarck stipulated that 7.5 metres (24 feet) of garden on all sides of each house, 4 metres (13 feet) of pavement, 10 metres (33 feet) of road, 5 metres (16 feet) of bridleway and 5 metres (16 feet) of central promenade were to be allowed the entire length of the street. With a total width of 53 metres (174 feet), the Ku'damm was once the grandest and most spacious boulevard in the capital.

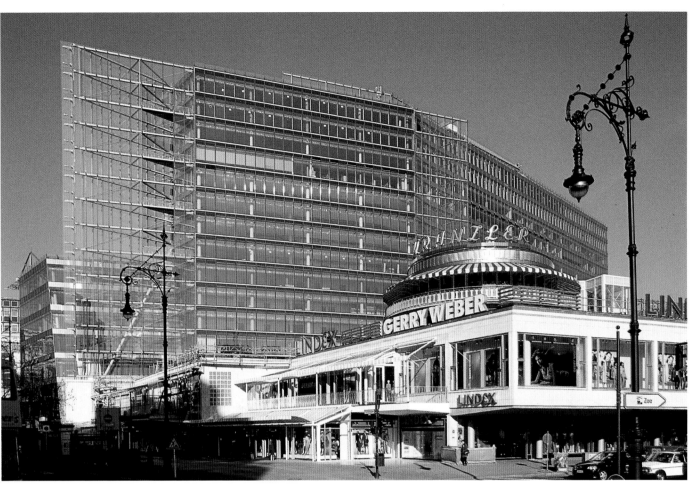

Café Kranzler on the corner of Kurfürstendamm and Joachimsthaler Straße is positively legendary. Its architecture effuses the spirit of 1950s like no other edifice of this period. The refurbishment carried out at the end of the 20th century has done little to change this.

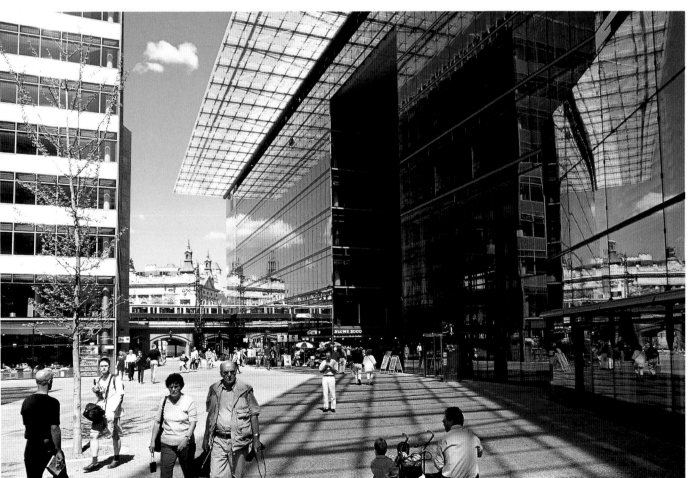

Helmut Jahn's Neues Kranzler-Eck city quarter provides over 71,000 square metres (23,300 square feet) of floor space on a plot just 20,000 square metres (65,600 square feet) in size. The aviaries in the courtyard are worth seeing for their proportions alone, measuring 20 metres (65 feet) in diameter and up to 24 metres (80 feet) in height.

Fasanenstraße has several attractions. There's the Literaturhaus with its café and bookshop and the relatively new Galerie Raab which has earned a name for itself through Rainer Fetting and his artistic circle. There's also the Käthe Kollwitz Museum at number 24, the oldest house on the street.

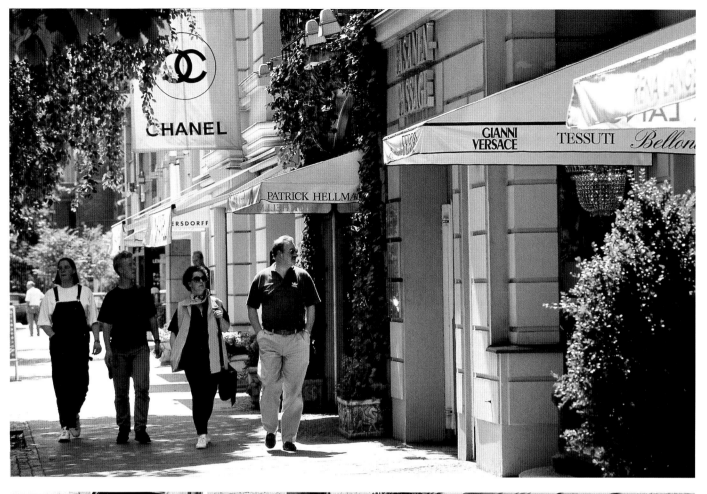

Leysieffer, the traditional family confectioner's, was set up in Osnabrück in 1909. They now have branches of their cake shops and cafés all over Berlin, such as here on the Kurfürstendamm, and also at the Hotel Adlon, Tegel Airport, in Grunewald, on Friedrichstraße and in KaDeWe.

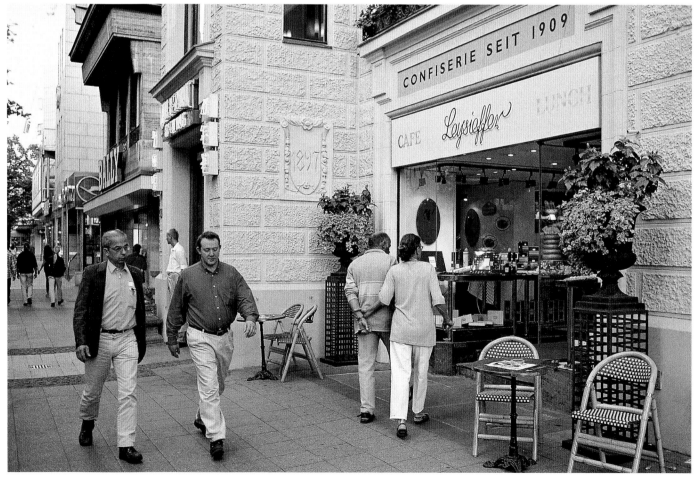

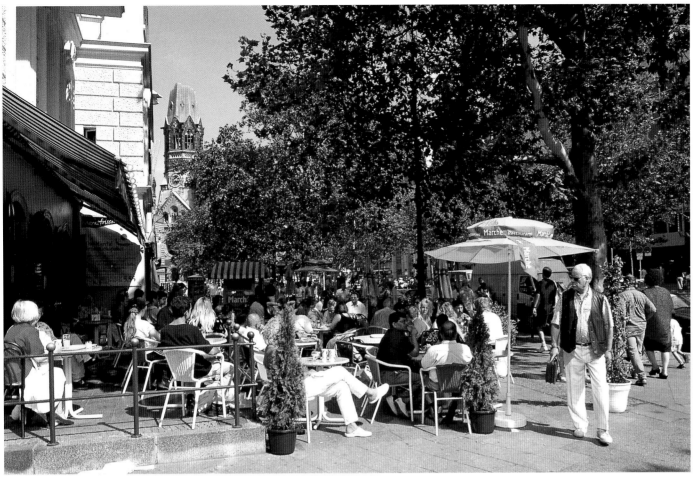

If you're planning on walking the entire length of the Ku'damm, setting off from Wittenbergplatz, you might feel like taking your first break when you get to the Marché. Its cheerful market atmosphere and freshly prepared food provide a welcome respite from shopping and sightseeing.

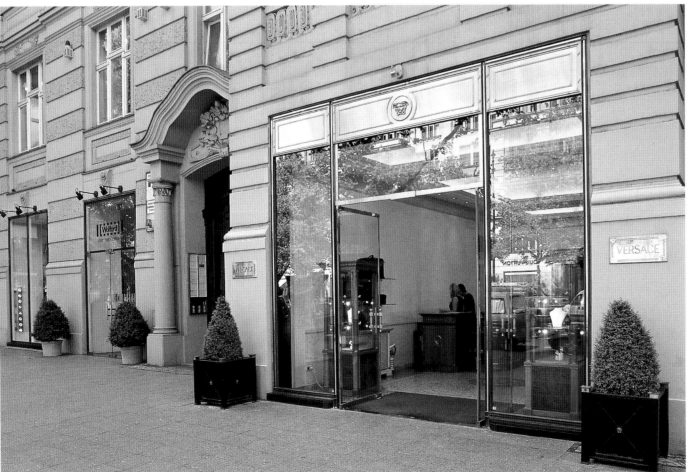

The middle section of the Ku'damm between Bleibtreustraße and Olivaer Platz is home to the big names in fashion. Designer goods from Bulgari to Cartier and Chanel, from Versace to Louis Vuitton can be had here – at a price…

69

Designed in 1928 by
Erich Mendelsohn as the
biggest cinema in Berlin,
in 1981 the Schaubühne
moved from the Halle-
sches Ufer to Lehniner
Platz. The building was
listed in 1979 and now
houses an established
theatre of the avant-garde
which Peter Stein, Bruno
Ganz, Jutta Lampe and
others have helped to make
internationally famous.

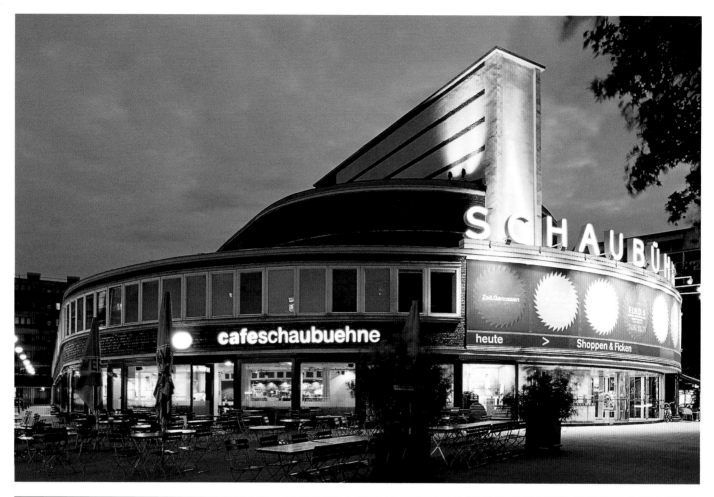

The Theater des Westens,
built for performances
of classic operetta in
1895/96, is also where
musicals are staged. Here
it is lit up for the Festival
of Lights which has been
held here once a year
since 2005.

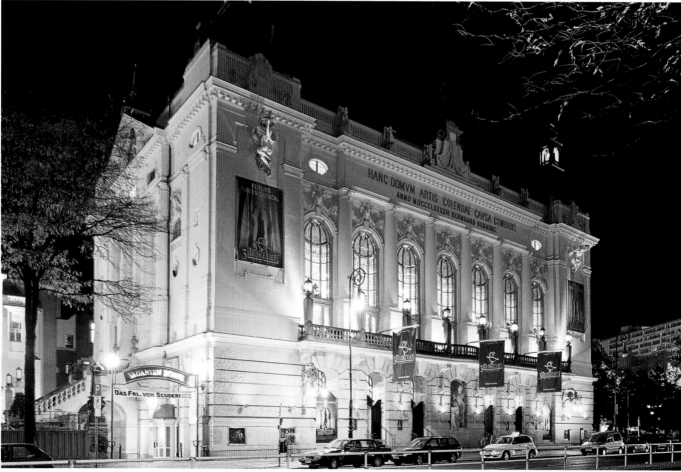

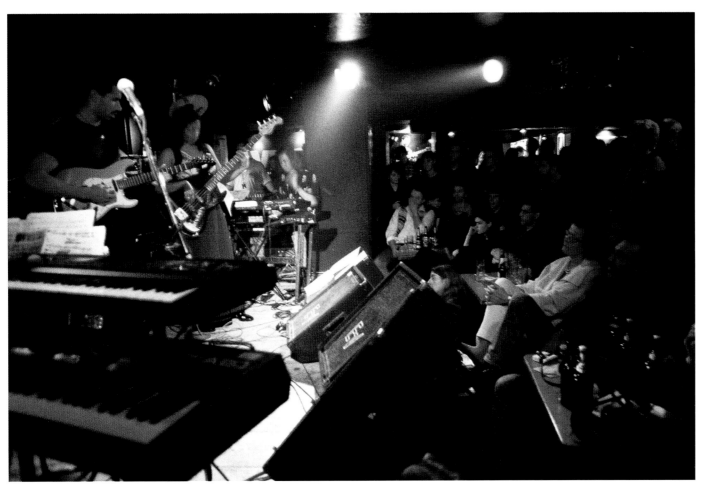

The Quasimodo jazz club is one of the oldest in town and undoubtedly one of the most famous both in and beyond Berlin. First-class live music has been on offer here since 1975 and the atmosphere is always unique. The club café is also a good place to end the evening after a trip to the nearby Theater des Westens.

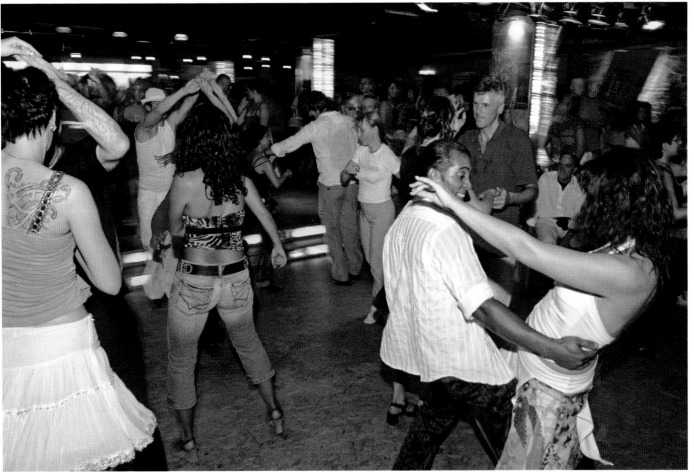

Hot Latin rhythms are back in style. At the Havanna salsa club in Schöneberg you can bop the night away on four dance floors and at seven bars – with regular instruction on how to execute the fanciest footwork.

Page 72/73:
The Philologische Bibliothek at the Freie Universität in Berlin was built under the auspices of renowned British architect Lord Norman Foster. The shape of the new interior building has earned the library the nickname of The Berlin Brain.

71

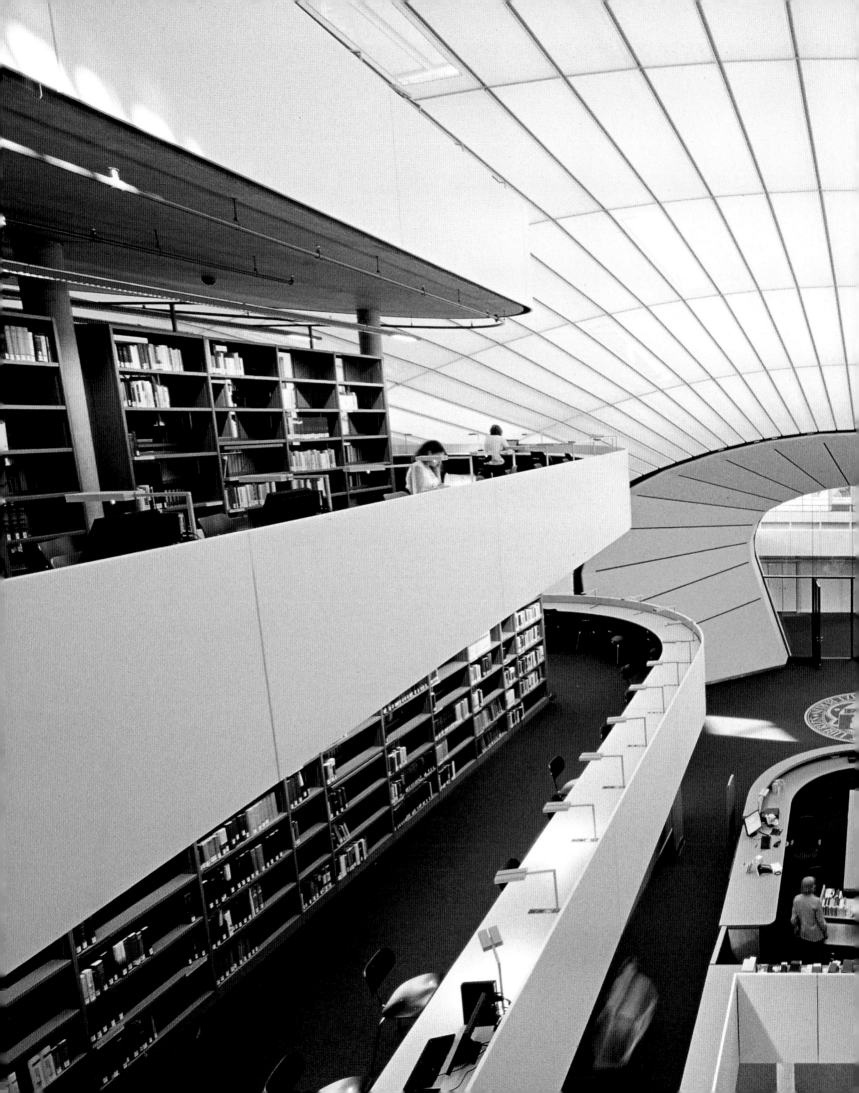

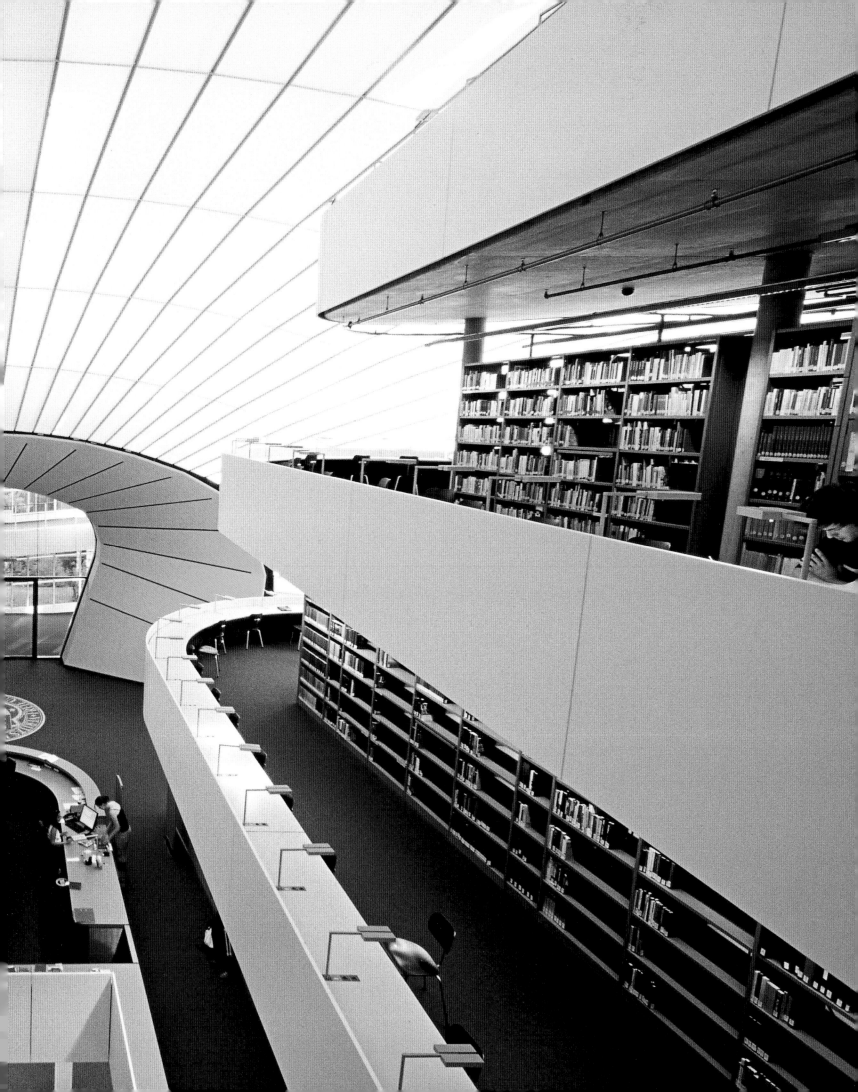

The new museum of technology on Landwehrkanal has been designed with its purpose in mind. Full of technical innovations, the building is low on energy consumption and has been erected so that its construction and technology are clearly visible. A "raisin bomber" from the Berlin Airlift of 1948/49 swoops low over the roof.

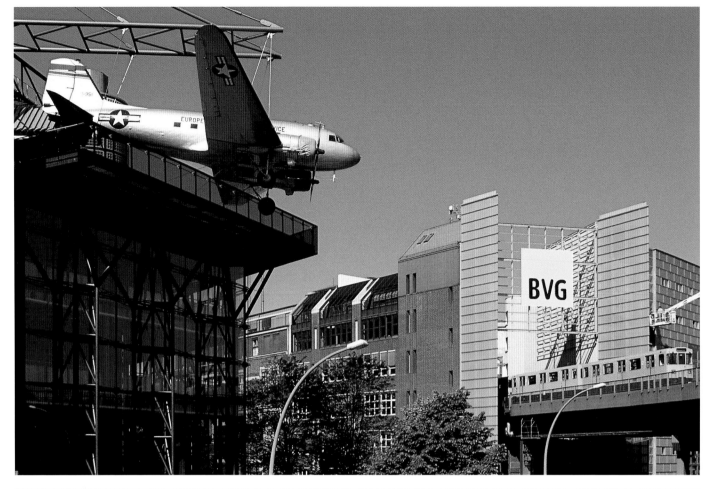

The double wall of the new university library is not only futurist in its design; it also cleverly regulates the temperature of the building. Once again Lord Norman Foster has proved that contemporary architecture doesn't just have to be conspicuous and unusual; it can also be ecologically sound.

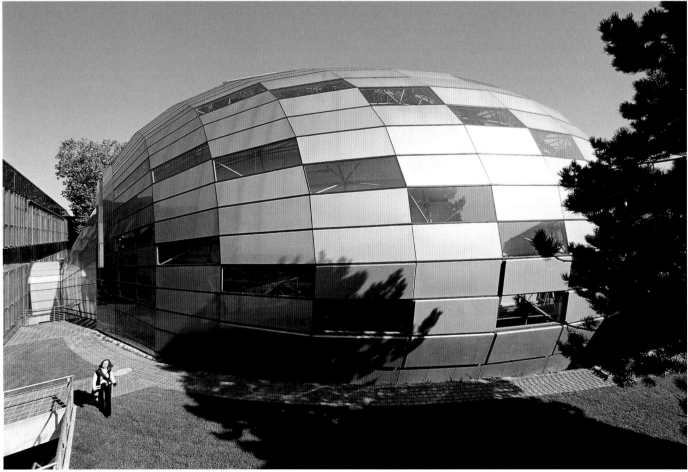

A gleaming layer of zinc smothers the Jewish Museum in Kreuzberg whose smooth facade is broken by an irregular smattering of slit windows. The building's unusual plan, the work of Daniel Libeskind, resembles a flash of lightening.

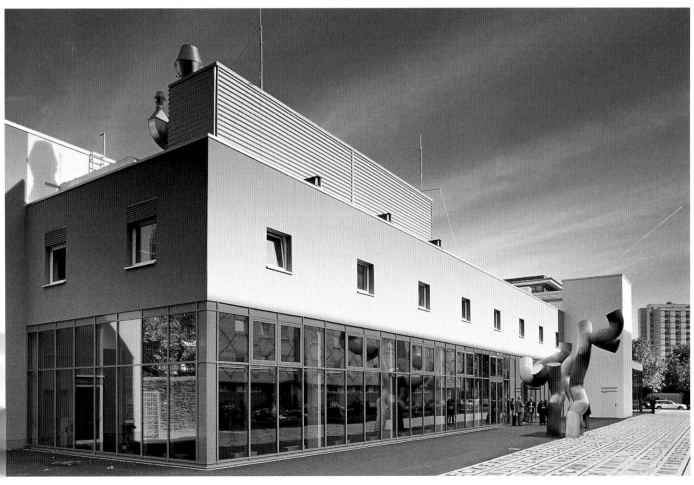

Unusually for modern architecture in Berlin the rebuilding of the Berlinische Galerie on Alte Jakobstraße took just one year, in which a glass warehouse from 1965 was perfectly adapted to accommodate a new museum of contemporary art.

At the yearly Festival of Lights the city's most impressive buildings are treated to a laser light makeover. Schloss Charlottenburg, shown here, is one such local landmark, built to demonstrate the power and might of Prussia. The historic interior is no less impressive than the brightly illuminated exterior.

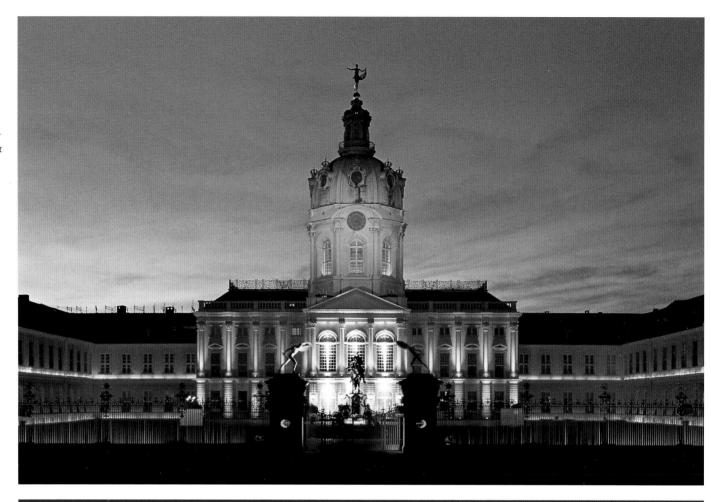

At the end of October the Festival of Lights turns Berlin into a glittering showpiece. The cathedral, depicted here, was once the head church of the Protestants of Prussia and is still one of Old Berlin's most prestigious constructions. Following its recent restoration the vault of the Hohenzollern dynasty has again been opened to the public.

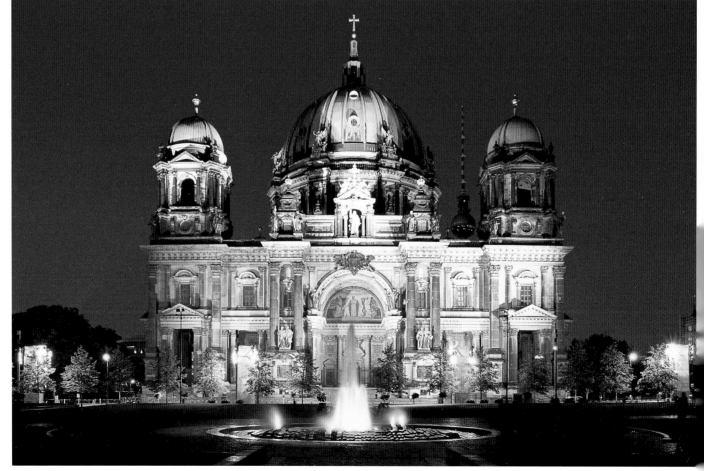

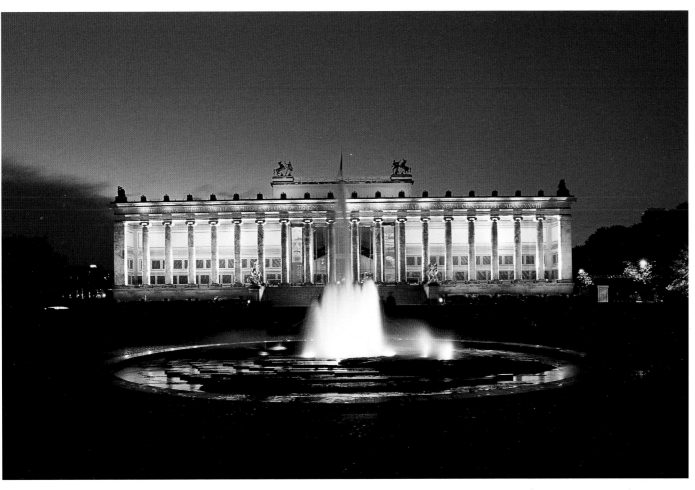

The Lustgarten, seen here in a futurist glow, is where in 1649 Prussia's first potatoes were planted. After being used as an ornamental and kitchen garden it was a parade ground under Friedrich Wilhelm I. The heavy granite dish in the park, carved from a huge boulder found in the Mark Brandenburg, is known as "Berlin's biggest soup bowl".

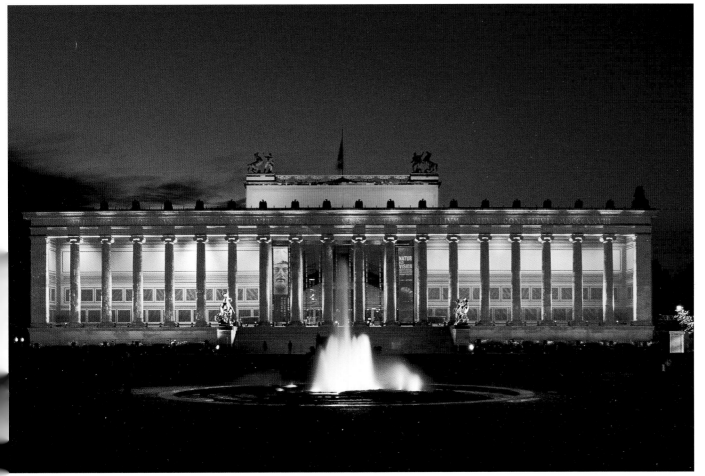

The Altes Museum in the Lustgarten has been illuminated in hues of orange for the Festival of Lights. Opened in 1830, the building is a major product of the neoclassical period. It was designed by Karl Friedrich Schinkel, born in Neuruppin in 1781, who also created the Neue Wache on Unter den Linden and the Neues Schauspielhaus on Gendarmenmarkt.

Page 78/79:
The International Congress Centre, Berlin's very own Starship Enterprise, is something of a bone of contention to the locals. Its capacious exhibition centre perched beneath the telecommunications tower is nevertheless where the city's biggest fairs are held, among them the Grüne Woche, the Internationale Tourismusbörse and the Internationale Funkausstellung.

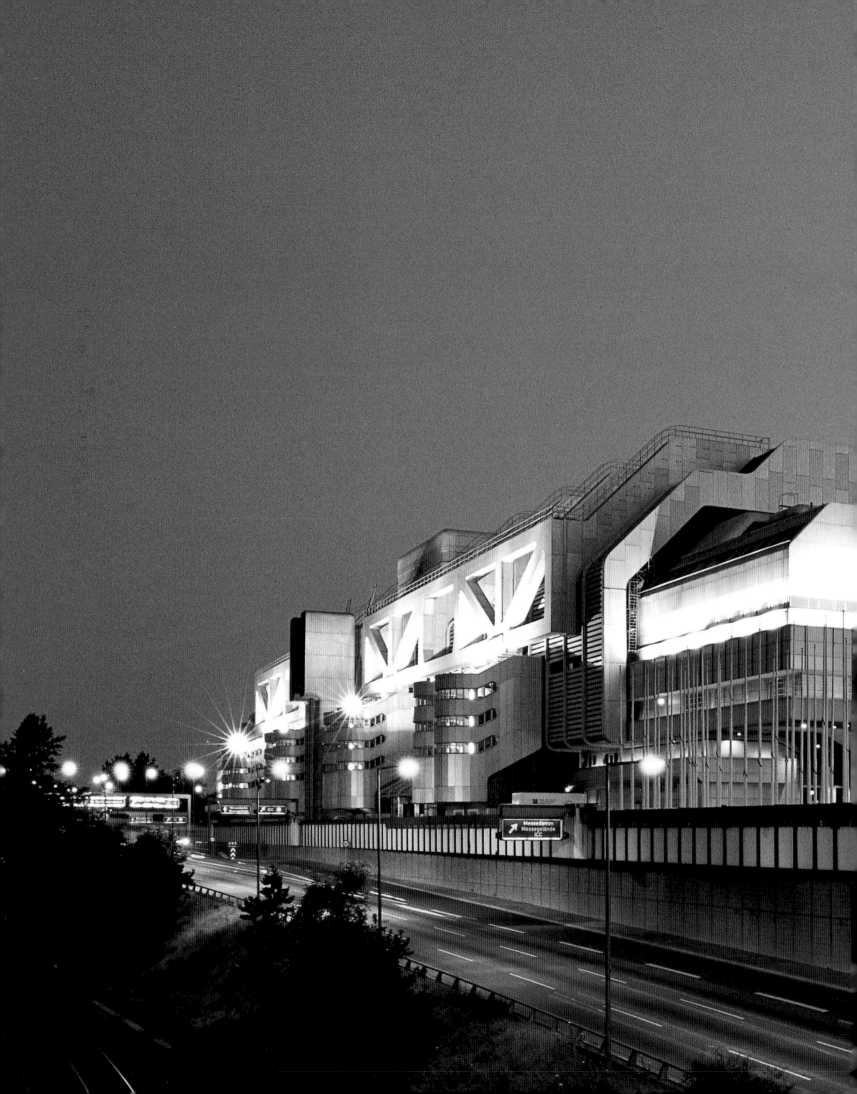

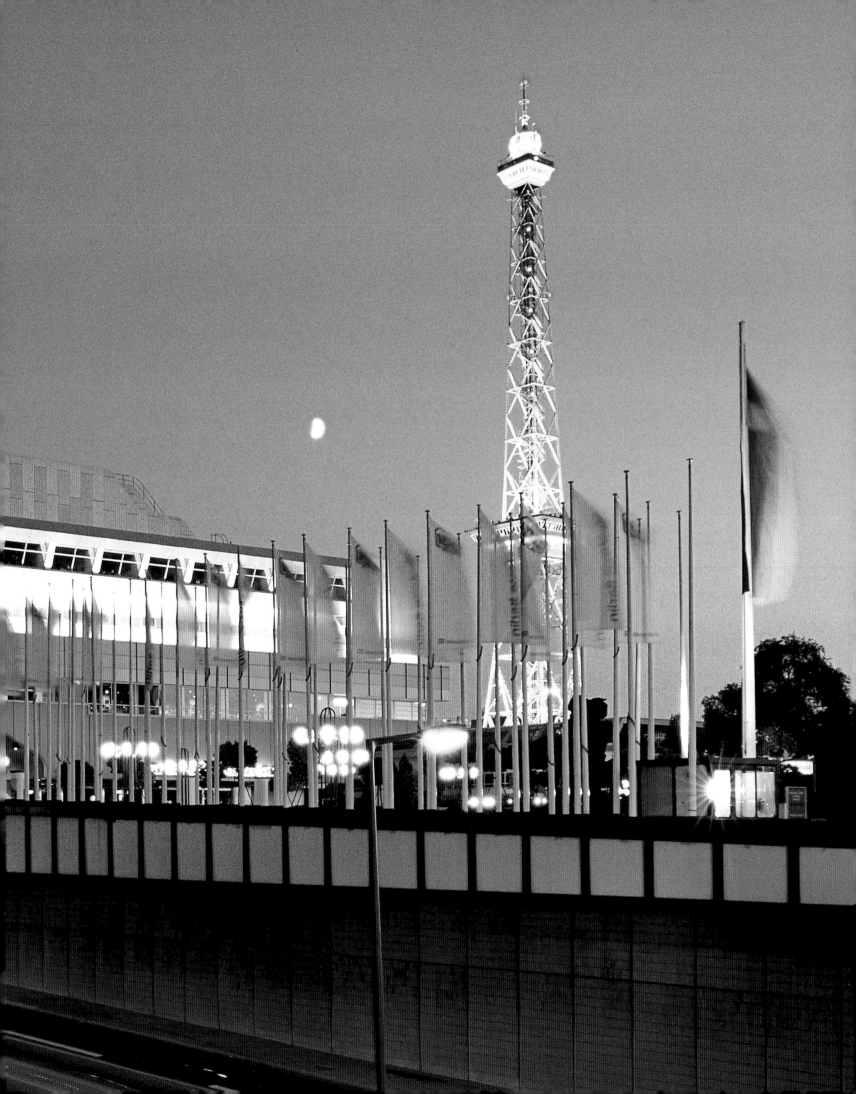

Palaces, parks, gardens and forest – Berlin's green belt

Which is the best time of year to be in Berlin? All year round! Admittedly spring is perhaps the most charming when the trees are cloaked in fresh green, everything is in bloom – and the people of Berlin can do what they like doing best in the great outdoors. Keen gardeners hurry off to their allotments, farmers in Lübars just have to step out of their front doors to be in the fields; townies flock to the pavement cafés or take a trip out 'into the sticks'. The Mediterranean atmosphere of Athens on the Spree in spring is guaranteed to put even the grumpiest Berliner in a good mood!

Whether you fancy a barbecue in the Tiergarten, a stroll through the Japanischer or Chinesischer Garten or a tour of the Botanischer Garten, one of Berlin's many parks is bound to be on your doorstep. Some take delight in the regular re-enactments of *Der Hauptmann von Köpenick* staged outside Köpenick's historic town hall; others prefer to meander through the art galleries and museums of Berlin's palaces, with lush parkland on offer at Schloss Charlottenburg and Schloss Glienicke for a post-cultural saunter in the fresh air. The hunting lodge in Grunewald even has access to various hiking trails and cycling tracks for the more active visitor.

Walking or cycling along the banks of the Spree and Landwehrkanal, through the Tiergarten or along one of the city's many tree-lined avenues is the perfect way to explore the capital. The less energetic can relax on board one of Berlin's many pleasure boats or double-decker buses and take in the view from there. The city's legendary underground and suburban railway network speeds locals and visitors alike to Spandau and Köpenick on the outskirts of town where country idyll awaits – so far from the metropolis and yet so near.

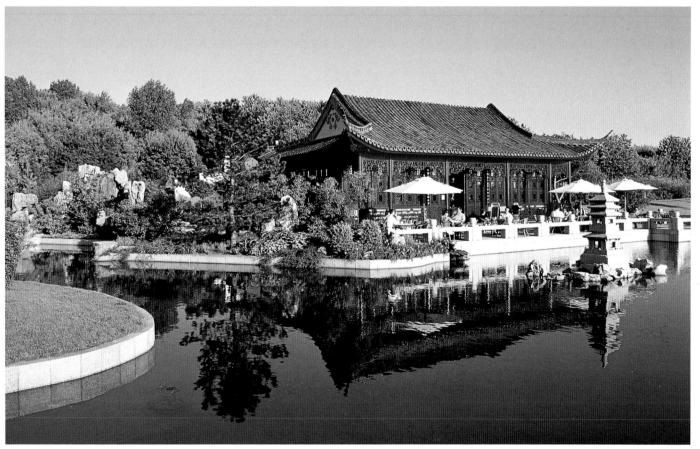

Above:
Much of Berlin is flat and
its highest 'mountains'
are little more than hills.
It is thus perfect for
cyclists, such as here in
the Tiergarten.

Left:
The Chinesischer Garten
was the first of Berlin's
Gardens of the World to
be opened in Marzahn in
2000. Covering an area
of 2.7 hectares (6.7 acres)
it's the biggest of its kind
in Europe. The Japanese,
Balinese, Korean and
oriental gardens have
now also been finished,
with more planned for
the future.

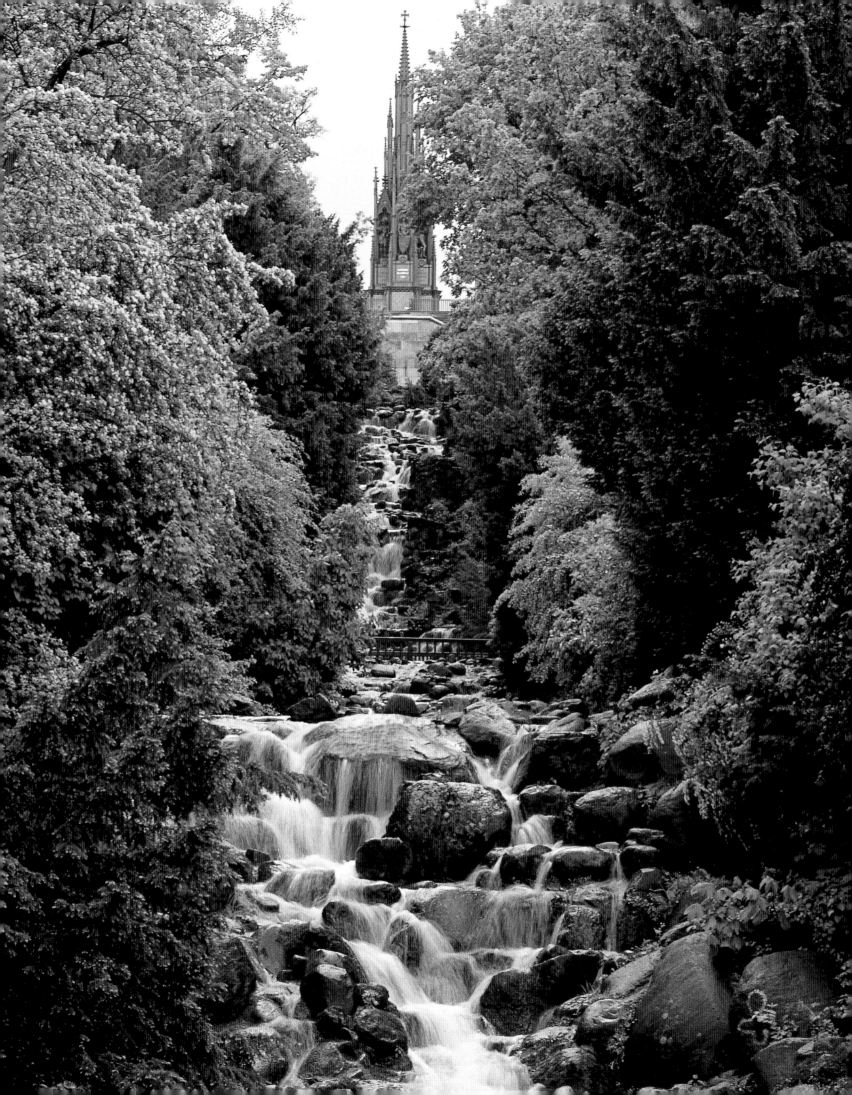

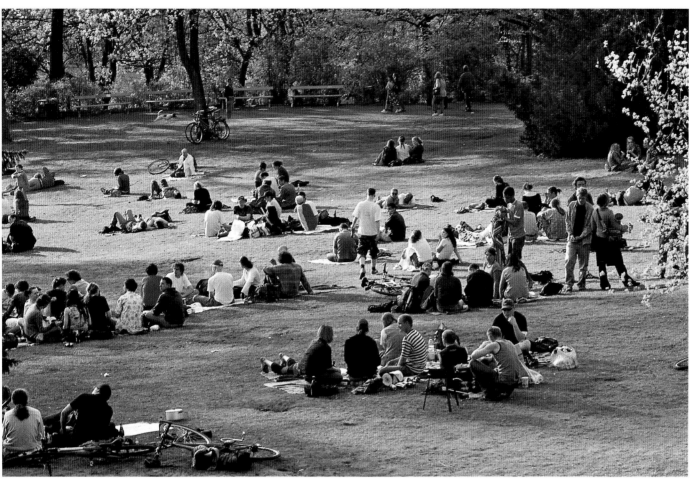

Left page:
The manmade waterfall in the Viktoriapark is modelled on the Zackelfall in the Riesengebirge and almost ran dry due to lack of funds. Behind it is the Schinkel Monument with its cross on top of the hill – which gave the popular area its name of Kreuzberg (literally: "mountain with a cross").

It may not be one of the biggest parks in town but it's certainly one of the most popular; the Viktoriapark has a pet's corner, a modest vineyard where grapes are again being cultivated and plenty of open spaces to take an afternoon nap in the sun.

Together with the cemeteries near the Hallesches Tor the burial ground in Dorotheenstadt is where many of Berlin's famous names have been laid to rest. Bertolt Brecht and Helene Weigel once lived next door and now rest in peace here. Former president of Germany Johannes Rau was interred here in 2006.

83

Schlachtensee not far from the S-Bahn station of the same name is one of Berlin's popular bathing resorts. It's located in Grunewald which was 'discovered' by the people living in the city centre at the end of the 19th century. Prior to this the forest was used as a hunting ground by Berlin's Prussian rulers.

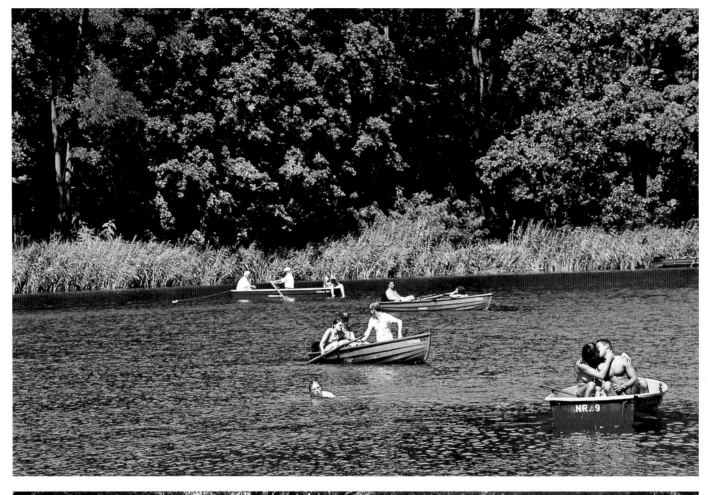

Berlin is not only one of the 'greenest' cities in Europe; its many expanses of water also vastly improve the quality of life here. Besides the Spree, Landwehrkanal and Havel rivers there are the lakes of Wannsee and Müggelsee – and many more smaller ones besides, such as the boating lake in the Tiergarten shown here.

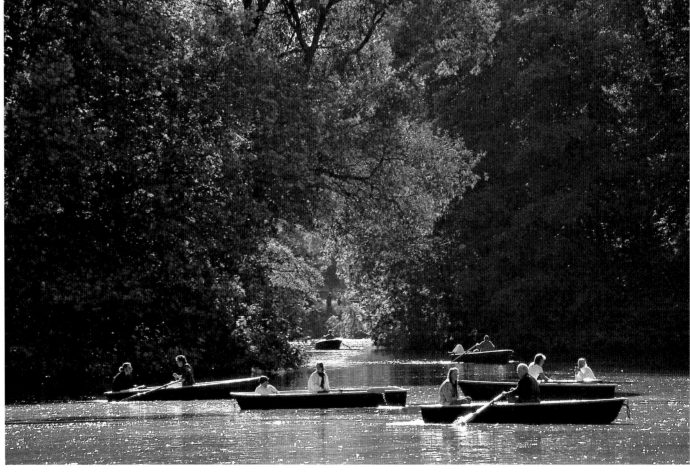

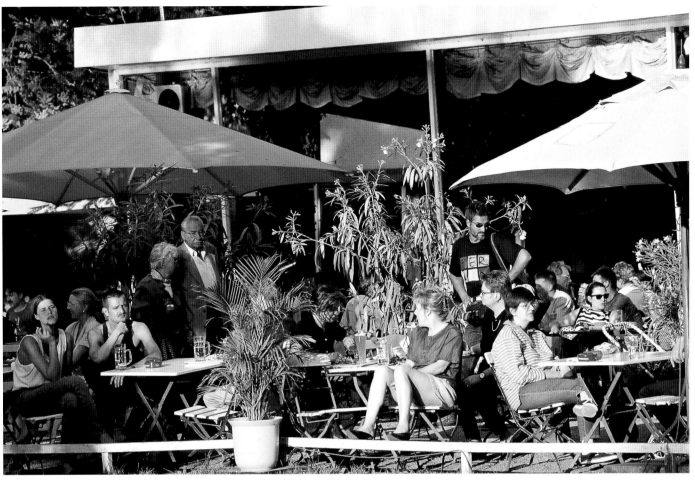

The idyllically situated
Café am Neuen See in
the Tiergarten is no longer
a backwater pub recom-
mended by word of mouth.
A quieter alternative is
provided by the Schleusen-
krug on the Landwehr-
kanal. No less revered
than the former, long
and intense negotiations
preceded its opening in
West Berlin in 1954 when
the city waterways were
still under East German
control.

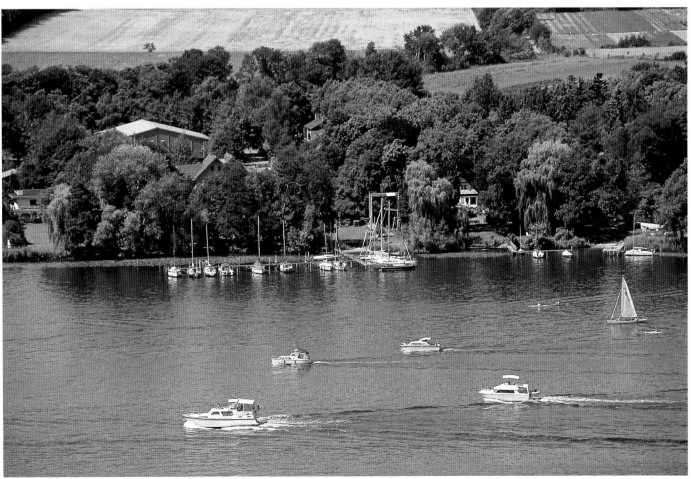

About 30 kilometres
(18 miles) of the River
Havel flow through
Berlin. The most scenic
stretches within the city
bounds are Schildhorn,
Lindwerder, Schwanen-
werder and the environs
of the Pfaueninsel. The
Havel's main tributary
is the Spree which flows
into it near Spandau.

With the king too mean to erect a completely new building, the Kavaliershaus on the Pfaueninsel from 1803/04 was extended in 1823 using bits of a late Gothic patrician house taken from Gdansk. The undertaking turned out to be more expensive than expected, however, prompting the monarch to then save on the interior decor – which is rather plain and simple.

The ever changing floral splendour of the gardens at the Liebermann Villa on the Wannsee inspired the famous Impressionist time and again. The villa has recently been opened as a museum. The intimate charm of Max Liebermann's private summer residence is especially evident in his daughter Käthe's old bedroom.

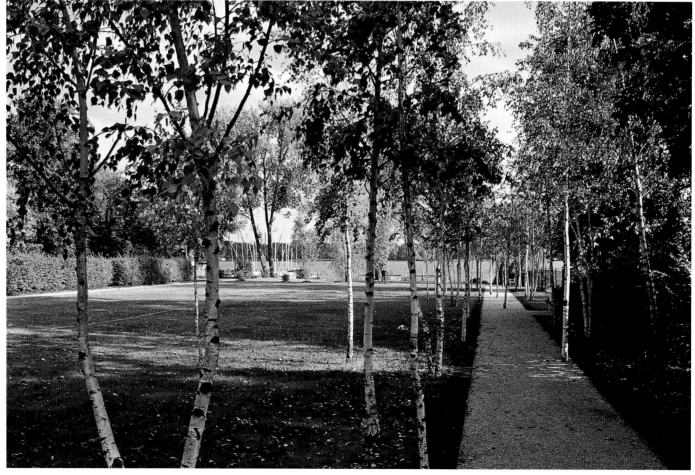

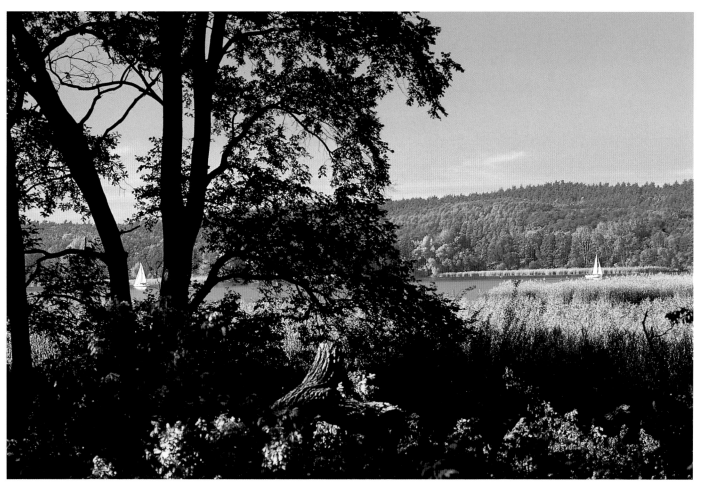

There are grand views of the River Havel from the Pfaueninsel. Originally where rabbits were once bred for the Gut Bornstedt in the authority of Potsdam, at the end of the 18th century the first buildings were erected on the island, some of them follies like the old castle. Exotic animals were introduced under Friedrich Wilhelm III, including the peacocks which gave the island its name (Pfaueninsel = peacock island).

Beginning in Berlin's last intact village, Lübars, beautiful hiking trails lead off into the surrounding countryside of the Mark Brandenburg and Tegeler Fließtal. Marshland and areas of tufa, xeric grassland and clear lakes provide local flora and fauna with what have become rare habitats – right on the edge of the metropolis.

Page 88/89:
The Siegessäule or victory column is not only popular during the Love Parade. The statue of Victoria atop the elongated pillar is known locally as "Golden Elsie" (Goldelse). Often full to bursting during the summer, on a cold winter's day a walk through the surrounding Tiergarten can be pleasantly quiet.

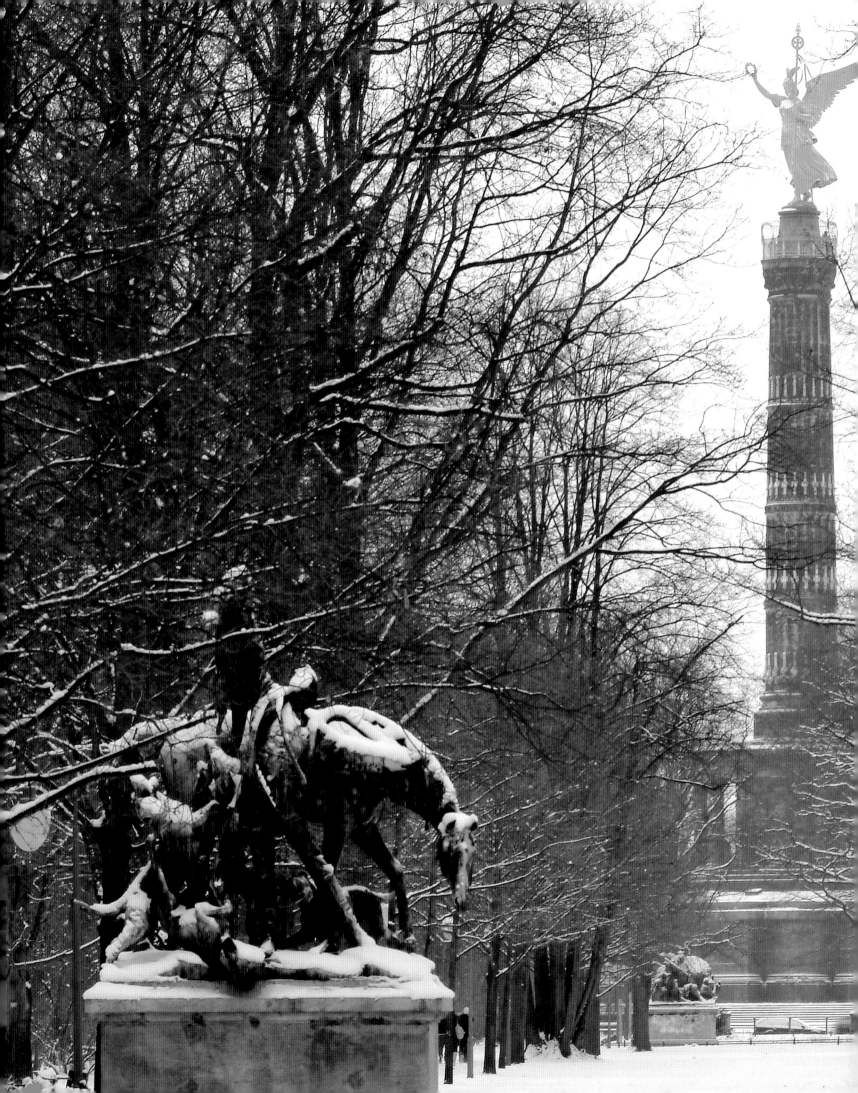

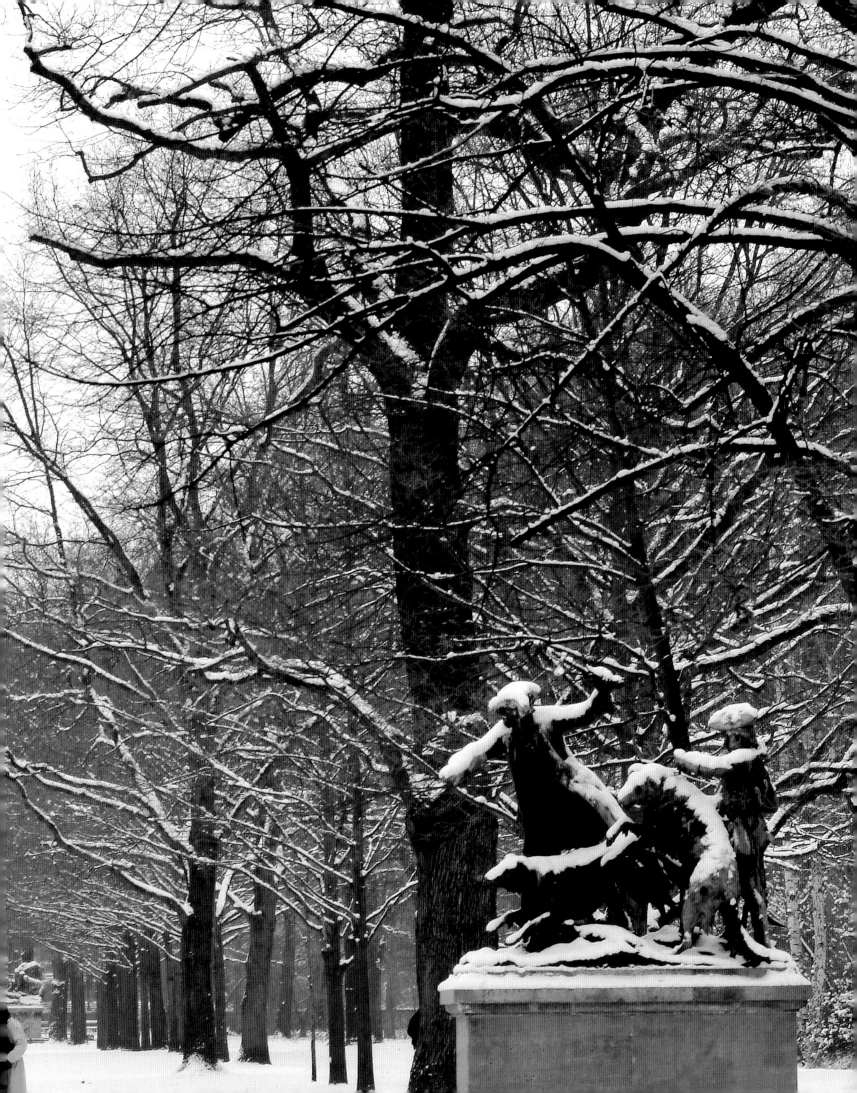

INDEX

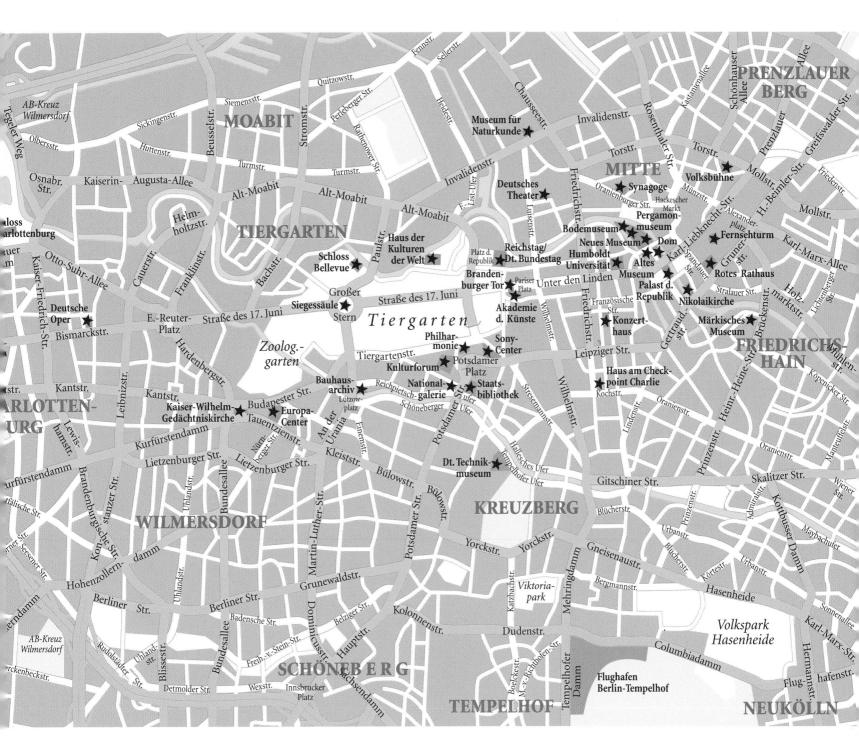

The Wannsee lido is nick-named the "bathtub of Berlin". Easily reached by a number of suburban railway lines from the centre of town it gets very busy here in the summer. This doesn't perturb the people of Berlin in the slightest; at the first sign of sun they're off to the beach…

Front cover:
Above:
Country idyll in the heart of the big smoke: the Café am Neuen See (or CANS) in the Tiergarten. In summer the beer garden's leafy trees provide respite from the sultry city heat. And if you feel like some gentle exercise after your (late) Berlin breakfast, there's always the chance of a spin on the lake.

Below:
The Brandenburg Gate and Pariser Platz hold great symbolism for the Reunification of Germany. A no-man's land for many years, today the area is used by banks, embassies and the fine arts. Locals and tourists alike come here to soak up the atmosphere of this historic place.

Back cover:
The tent roof which spans the buildings of the Sony Center is nothing less than impressive, with the 2,500 metric tons of steel and glass secured like a giant umbrella. By day and night the light plays on the roof in a fascinat-ing spectacle of shape and colour.

CREDITS

Design
hoyerdesign grafik gmbh, Freiburg
www.hoyerdesign.de

Map
Fischer Kartografie, Aichach

Translation
Ruth Chitty, Schweppenhausen

Printed in Germany
Repro by Artilitho snc, Lavis-Trento, Italy
www.artilitho.com
Printed/Bound by Stürtz GmbH Würzburg
© 2013 Verlagshaus Würzburg GmbH & Co. KG
© Photos: Martin Siepmann

978-3-88189-682-5

Details of our full programme can be found at:
www.verlagshaus.com